POSTCARD HISTORY SERIES

Around Dryden

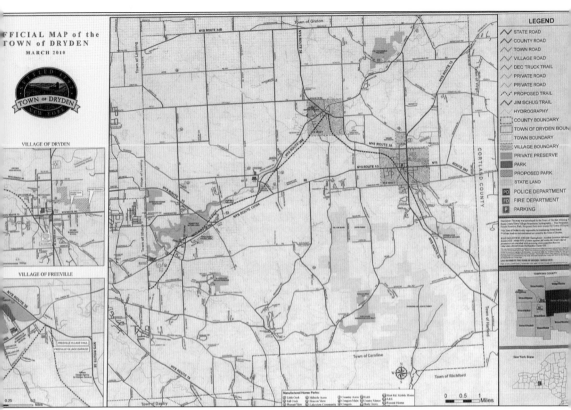

The official 2015 map of the town of Dryden, New York, can be found at the Town of Dryden Offices at 93 East Main Street, Dryden, New York. (Author's collection.)

ON THE FRONT COVER: The famous Dryden Cornet Band is lined up at the "four corners" of Dryden, New York, ready to step off during one of the annual Dryden Agricultural Society Fairs. (Courtesy of Dryden Town Historical Society.)

ON THE BACK COVER: These horses are heading westward toward Ithaca, New York, or possibly back to their homestead. (Courtesy of Dryden Town Historical Society.)

POSTCARD HISTORY SERIES

Around Dryden

Harry Lawrence DeBreuil Weldon

ARCADIA
PUBLISHING

Published by Arcadia Publishing
Charleston, South Carolina

Printed in the United States of America

Library of Congress Control Number: 2018939272

For all general information contact Arcadia Publishing at:
Telephone 843-853-2070
Fax 843-853-0044
E-mail sales@arcadiapublishing.com
For customer service and orders:
Toll-Free 1-888-313-2665

Visit us on the Internet at www.arcadiapublishing.com

To the memory of two of my high school teachers: Miss Eunice Gardiner, who sparked my lifetime interest and love of American history, and Miss Inez Cook, who always had a word of encouragement. God bless them both; may they rest in peace!

CONTENTS

ACKNOWLEDGMENTS

A heartfelt note of gratitude is expressed to Kathleen Elliot, now deceased, who inspired the creation of this book, and to her fellow members of the Collection Committee of the Dryden Town Historical Society, Inc. for their cooperation and their diligent support in rummaging through scores of files and sorting the many hundreds of photographs and postcards in their photographic collection.

Gratitude is also extended for those gracious opportunities to digitally scan the many special postcards by the Collection Committee chair of the Dryden Town Historical Society, Inc., Dryden, New York; to David Waterman, author of *Who Was This Amos Sweet?*, for loaning the book cover for inclusion herewith; to Bruce Beatty, Collegeville, Pennsylvania, and Patricia "Trish" Sprague, archivist of the William R. George Agency (also known as George Junior Republic), for the loan of their postcard collections; to Judy Auble-Zarrara and Saino Zararra for sharing the Etna Community Association postcards; and to Michael Murphy, Dryden Village mayor, for his devotion and friendship in completing this compilation. And a very special note of gratitude goes to Kayla Rose Morley, one of my seven grandchildren, for her unselfish dedication in proofreading and "flowering up" the entire text. To all, a simple thank-you just does not do them justice; that's for sure!

INTRODUCTION

Postcards first came to Austria in 1869 and were called *korrespondenz kartes*. These cards were unique because they could be sent through public mail without using an envelope and were therefore lighter in weight and less expensive to send. It was a handy way to send a brief message without the formality of a letter. Shortly thereafter, the advent of the picture postcard came around 1893.

In 1898, the United States passed legislation that would allow postcards to be mailed in the United States, Canada, and Mexico with a 1¢ stamp. Postcards for private use began with Eastman Kodak marketing and sales of cameras and papers that were specifically designed for postcard use. People would take pictures of their homes, farms, churches, ad infinitum and have them made into postcards. In the beginning, there was a small border on the front of the card where a short message could be jotted down. Beginning in 1907, the backs of these postcards provided room for the mailing address on the right and a blank area on the left for a personal message.

By the 20th century, almost every community had its own postcards for distribution. Photographs of residences and people were referred to as "vanity cards" and were often purchased by individuals who did not live in the home but found the structure to be of particular architectural or historical significance. When traveling, it was a convenient way to communicate what had been seen to family and friends.

Spanning over 100 years, this book displays the uniqueness of the town of Dryden, New York, and includes the villages of Dryden and Freeville, as well as the hamlet of Etna. Unfortunately, postcards of the other hamlets of Varna, Ellis Hollow, Bethel Grove, Malloryville, and West Dryden within the town were not found to be available for inclusion. These postcards are a record of houses, schools, farms, and businesses that permit a view of rural life over the years.

A composite study of the different types of postcards, not just picture postcards, informs any researcher delving into Dryden's history of the importance of utilizing these three-and-a-half-by-five-and-a-half-inch pieces of cardstock. Anybody, especially a researcher, can look at the postcards and look back upon old businesses, family affairs, and the occasional affectionate relationship. The postcards could be sent over the miles at a significantly low cost, even in the early days, of 1¢ per postage stamp. The pictorial records are a useful tool to a historian who would not otherwise have available a documented record of the location of a building or the whereabouts of an individual person who might be pertinent to local history. Artists often use old picture postcards to create a nostalgic, reconstructed view or a scale model of a now nonexistent structure.

Each instance is truly a thumbprint of American life set permanently in time through the picture postcard.

1672	Jesuit missionary Father Carheil visits the Cayuga Lake region and describes its beauty. Before 1779, the area was Native American territory.
1779	General Sullivan's campaign in the area results in the dispersal and humiliation of the Haudenosaunee Confederacy, opens the way for Revolutionary pensioners to settle.
1781	The Revolutionary War, for all practical purposes, ends.
1783	Preliminary surveying is taken of areas traversed by General Sullivan's campaign army.
1789	The New York State Legislature passes a law to have the entire wilds conquered by Sullivan's Army for the settlement of surviving veterans of the Revolution between Seneca Lake and the Oneida Lake, comprising almost 2 million acres to be known as the "Military Tract." This was divided into townships of approximately 100 square miles containing lots of about one square mile each.
1790	The Military Tract is surveyed. Township No. 22 is named Ulysses, and Township No. 23 is named Dryden.
1791	New York Revolutionary soldiers/veterans draw lots by ballot.
1793	Joseph Chaplin is contracted to build a road from Oxford, Chenango Valley, New York, to Cayuga Lake. He does complete the road to Ludlowville at Cayuga Lake through the northern section of Dryden Town but is refused compensation by the legislature for going to Ithaca as expected.
1794	Dryden is merged with Ulysses in a quasi-governmental merger for lack of having any settlers; having been included in Onondaga County and prior to being a part of Tioga County; earlier encompassed in Montgomery County.
1795:	Chaplin completes the task of building a road, veering off his first route just west of Virgil, New York, and passing through what later becomes the village of Dryden. This second road becomes known as the "bridle road" because it required sledges and wagons pulled by animal teams to be led by a bridle.
1797:	Amos Sweet becomes the first settler in what later becomes Dryden Township, at this time a part of Ulysses Township.
1800:	US Census is taken. Dryden is included in the Town of Ulysses, Cayuga County, New York State.
1801:	Amos Sweet is forced to vacate his claim, for dubious reasons.
1802:	At a Ulysses meeting, representatives vote to set off Dryden Township.
1803:	Dryden Township is set off from Ulysses by an act of the New York State Legislature. George Robertson is named the first supervisor of Dryden Township (also later known as the town of Dryden.)
1804:	The first school in Dryden Township opens in Amos Sweet's former log cabin.
1805:	Simeon Dewitt's map of New York State is first published.
1815:	First post office is established in Dryden Township.
1827:	Slavery is abolished in New York State. Also, the Eight Square School House is built in Dryden.
1857:	Village of Dryden is incorporated, with a population about 400.
1865:	Village of Dryden is reincorporated.
1870:	Southern Central Railroad is in full operation in Dryden.
1887:	Village of Freeville is incorporated.
1890:	Lehigh Valley Railroad takes over many smaller roads in Tompkins County, including the Southern Central.
1895:	George Junior Republic is established between the villages of Dryden and Freeville.
1897:	Dryden Centennial is celebrated.
1902:	Rural free delivery mail service is established in Tompkins County.
1997:	Dryden Bicentennial is celebrated.

One

THE TOWN OF DRYDEN

The area known today as the town of Dryden was originally heavily forested with hemlock, hardwoods, and white pine. The land was actively used by the Haudenosaunee (Iroquois) as a hunting ground. Native American tools have been found in the area. After the Revolutionary War, these lands were surveyed in 1790 and became Township No. 23 of the Central New York Military Tract. Thence, the lands were set aside for settlement by surviving Revolutionary veterans, many of whom traded or sold their land grant titles to people in other states. Simeon DeWitt, surveyor general of New York State, named the township after the English poet John Dryden. Dryden had done so much to bring the ancient Greek and Roman epics of, respectively, Homer and Virgil to English readers. Dryden would rightly take its place among communities named for these great classical poets. By 1797, the first settlers from the more eastern areas showed up to clear land.

Arriving in 1797 with his family, Amos Sweet is credited as being the first settler in this township. Many of the first settlers came from New Jersey, Connecticut, Massachusetts, Pennsylvania, and the many parts of New York State. Dryden was formally organized on February 22, 1803, and in 1817 it became part of Tompkins County. An official roadside historic marker can be found placed at the right of the entrance portico of the Dryden Town Hall as a testament.

A whimsical postcard was often mailed just to let the recipient know that someone was thinking of him or her. (Courtesy of Dryden Town Historical Society.)

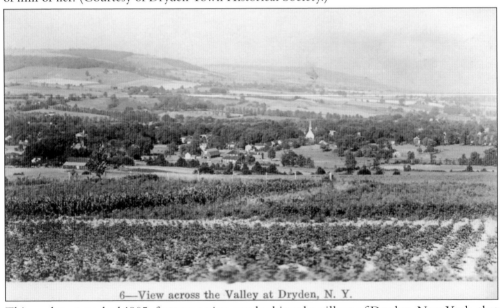

6—View across the Valley at Dryden, N. Y.

This card, postmarked 1905, features a vista overlooking the village of Dryden, New York, that apparently faces the south hill side. There, in the very center of view, is the Dryden Methodist Church with its tall spire pointing skyward, as if indicating for all to see the heavens above. Slightly more in the northeast foreground is the 12-sided Agricultural Fair building. Today, experimental agriculture fields and state-of-the-art dairy farms are found on large tracts of lands within Dryden Township (town of Dryden) and, because of the closeness of Cornell University and the proximity to Syracuse and Binghamton, there have been a number of start-up businesses in the area over the years. (Author's collection.)

This is an artistic pen-and-ink rendering by David Waterman, used on the cover of his book *Who Was This Amos Sweet?* Local lore and established history credits Sweet as being the first settler in what was to become the town of Dryden. He is documented in other historical sources to have died in the spring of 1801 and is supposedly buried in an unmarked grave off of Spring Road with other members of his family in the village of Dryden. Waterman's publication is a provocative study of the Amos Sweet family's arrival and later departure to Attleboro, Massachusetts. (Courtesy of David Waterman.)

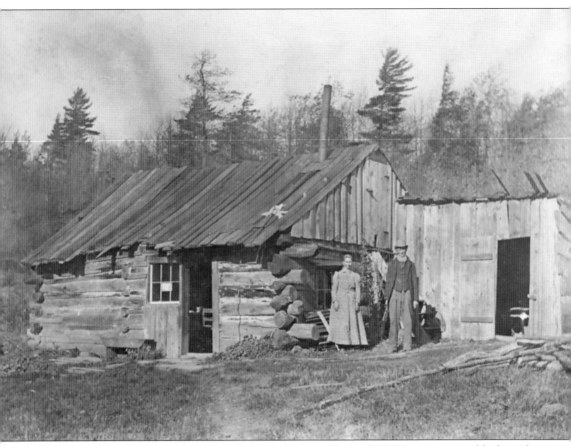

This log home in the town of Dryden was the dwelling of William Sweet, a blacksmith. The fact that he and the town's first settler in 1797, Amos Sweet, shared the same last name led many to believe that this was Amos's log cabin or that of his son. However, this is not likely, as photography was not yet a known media during this period of Dryden's history. The cabin is otherwise typical of log homes built in the area. (Courtesy of Dryden Town Historical Society.)

Two

VILLAGE OF DRYDEN

The village of Dryden was incorporated in 1857 and is approximately one square mile in the northeast quadrant of the town. The village was established with a population of 400 people and was reincorporated in 1865 without changing the acreage. Prior to the initial incorporation in 1857, the area was affectionately referred to as "Dryden Four Corners" to differentiate it from the entire town, which covered 100 square miles. The population was recorded at 1,890 according to the 2010 US census. Within the village, 44 properties comprise the Dryden National Register Historic District, which was established in 1984 and includes buildings constructed between 1800 and 1905. Several of the buildings are also listed individually in the National Register of Historic Places. In 1997, Dryden celebrated its bicentennial anniversary by unveiling a replica of the fountain that was scrapped in 1942 to provided funds for the World War II Allies in their fight for world freedom. The village of Dryden has a current population of approximately 2,000 people, remains the largest community within the town of Dryden, and serves as the business and administrative center for the town. It stands today as an attractive and lively village community.

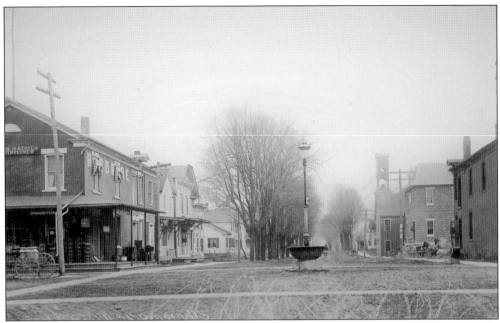

No one seems to be about on this day in 1895. Perhaps it is one of those spring sunrise mornings at the four corners of Dryden, seen in this view looking due south down the Owego Valley toward Dryden Lake. Note the horse watering trough around the light pole. (Courtesy of Dryden Town Historical Society.)

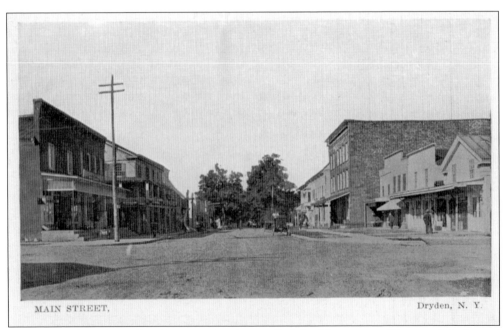

MAIN STREET, Dryden, N. Y.

The center of Dryden Village has over time been called the "four corners" because it is situated at the intersection of two main roads. This view from the east is looking down West Main Street in the direction of the city of Ithaca in the late 1920s prior to where the current four-way traffic light is located. (Author's collection.)

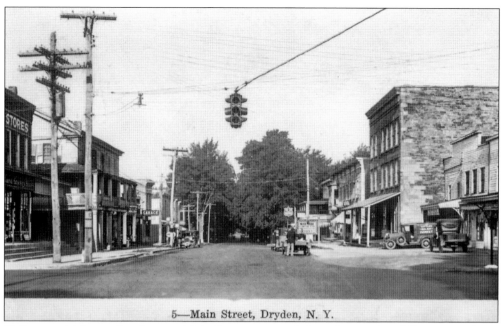

5—Main Street, Dryden, N. Y.

Delivery vehicles are lined up on Main Street to start their early morning delivery rounds. In this view looking down past the light, the former Eagle Hotel is visible on the left, and on the right are a meat market and a three-story stone mercantile building. (Courtesy of Dryden Town Historical Society.)

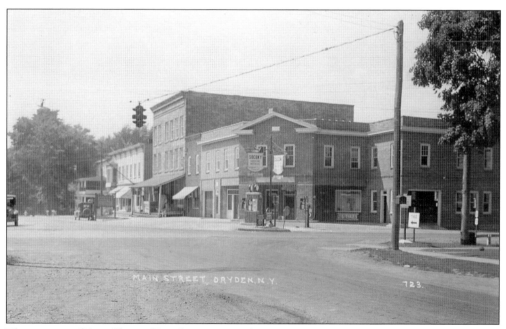

The corners of the village of Dryden appear to have some action on this typical weekday. There is enough automobile traffic to warrant a four-way traffic light. One of many future gasoline distributors to do business at this corner location, the Socony gas station is open for business. (Courtesy of Dryden Town Historical Society.)

This Dryden Time Square is not to be confused with Times Square in New York City. The Dryden square is located where there used to be gas stations such as Socony, as described on the previous page. (Author's collection.)

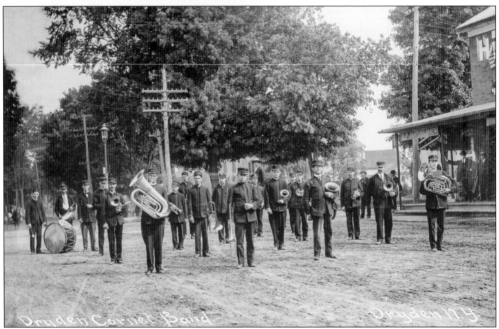

The famous Dryden Cornet Band is lined up at the four corners, ready to step off to the tune of a spirited march. This band was an integral segment of the grandstand entertainment during the annual Dryden Agricultural Society Fair, which ended in 1918. (Courtesy of Dryden Town Historical Society.)

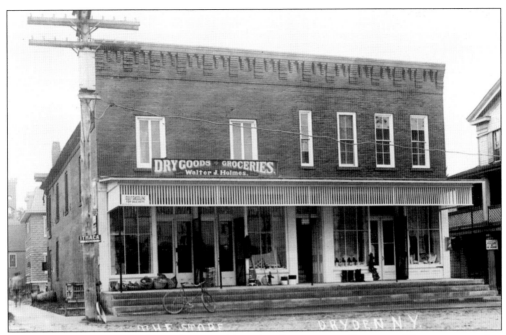

In 1915, this corner was obviously a good location for a mercantile store selling, among other things, groceries and dry goods. On the right half of the building was the location of another shop. Today, this building is the Dryden Community Center Café, with a print shop next door. The entire building was originally constructed by John Southworth in 1836, around the same time he built a home of bricks made from on-site clay. (Courtesy of Dryden Town Historical Society.)

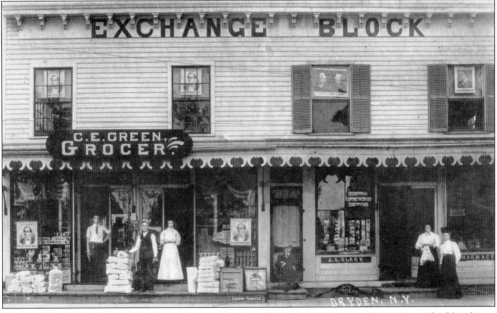

Pictured is the Exchange Block on the south side of West Main Street. C.E. Green had his large grocery store at this location for many years. Over time, it has been home to numerous different stores. In 1958, it was a drugstore and variety store. Today, there stands a florist shop. (Courtesy of Dryden Town Historical Society.)

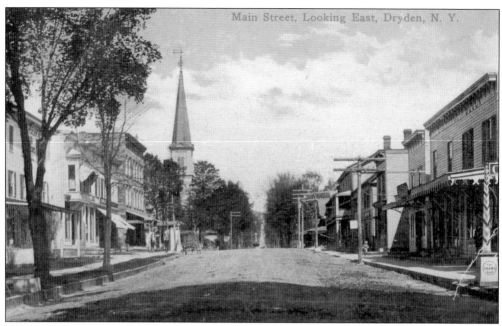

In this view looking to the east, the road in the distance goes straight over the far distant hill. This is because the road cut by Joseph Chaplin in 1795 follows earlier surveyor markers. The Dryden Methodist Episcopal Church spire dominates the view flanked by the ever-busy section of the village. (Courtesy of Dryden Town Historical Society.)

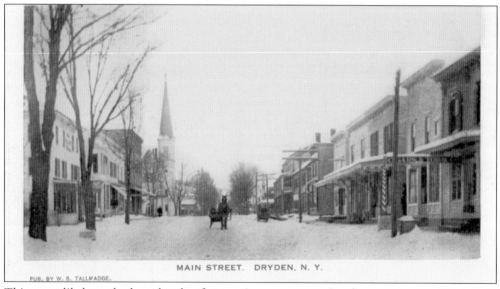

MAIN STREET. DRYDEN, N. Y.

PUB. BY W. S. TALLMADGE.

This scene likely took place shortly after sunrise on a snowy Sunday morning on West Main Street; the view is looking east back to the four corners and a horse sleigh makes its way down the street. Towering behind is the spire of the Methodist church that was constructed in the Romanesque Revival style. In the far center, hidden behind the sleigh, is a horse-watering trough set there when the village water system was refined around 1895. (Courtesy of Dryden Town Historical Society.)

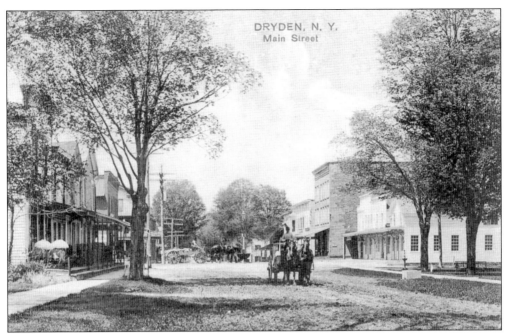

The village awakes before the coming of automobiles to its streets. One team of horses has stopped at the four-way intersection for a quick drink or two of water before heading out of town. Another team and its draw load is headed westward toward Etna, possibly Ithaca, New York, or back to its home farm. (Courtesy of Dryden Town Historical Society.)

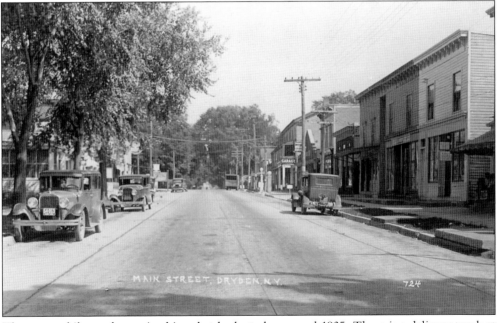

The automobile age has arrived in what looks to be around 1935. There is a delivery truck at the corner store. The former Eagle Hotel is seen on the south side of the street with a second gas station next door. (Courtesy of Dryden Town Historical Society.)

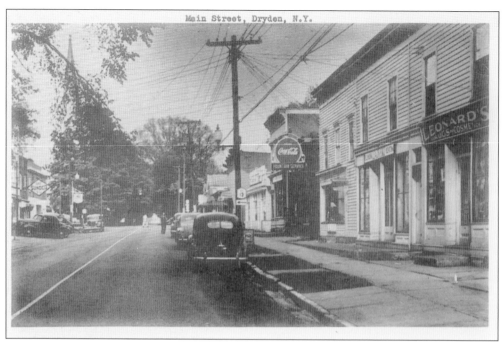

A closer look during the early 1940s gives a view of the south side of the village's main street. A new gas station under the name Sunoco is on the north side near the corner Mobil station, which had replaced the previous Socony station. At the four corners, note the jaywalker who is ignoring all the posted highway markers that take away from the picturesque views of Dryden's village. (Courtesy of Dryden Town Historical Society.)

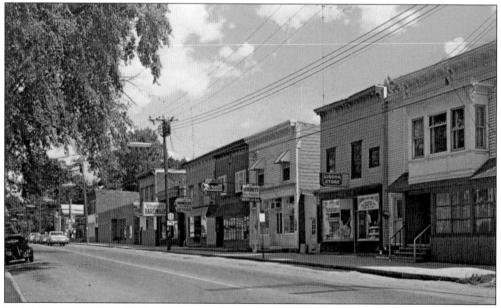

This is a more modern 1970s view of Dryden's main business section. In the foreground are the sign for Leonard's Variety Store and the soda shop sign for Ma Bailey's. During the long years of Prohibition, Ma Bailey's was a great place to be served a delicious cup of "specialty tea." (Author's collection.)

The four corners of Dryden are buried after a winter storm in 1914. It is likely that the merchants were out early to clear the sidewalks for the shoppers expected that day, despite the heavy snows. The spire of the Methodist church thrusts itself above the snow blanket to herald the landmark location. (Courtesy of Dryden Town Historical Society.)

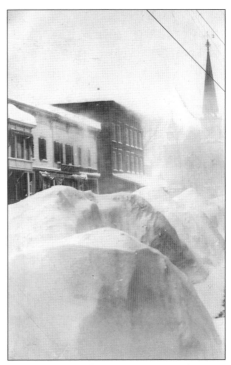

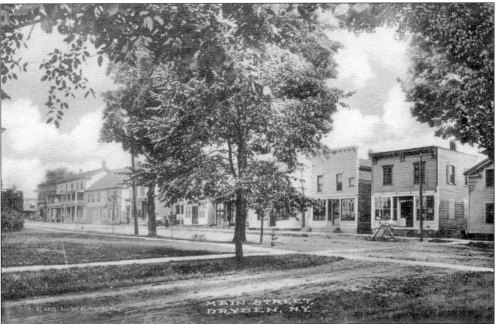

Looking east down West Main Street, the view from the corner of Library Street is quite intriguing. Few people or vehicles are seen. The image appears to have been taken before sunrise, as noted by the shadows angled towards Ithaca, New York. The former three-storied wooden Eagle Hotel stands tall and proud near the four corners. Years later in its demise, part of the former hotel was the headquarters of the infamous men-only "Spit & Whittle Club." (Courtesy of Dryden Town Historical Society.)

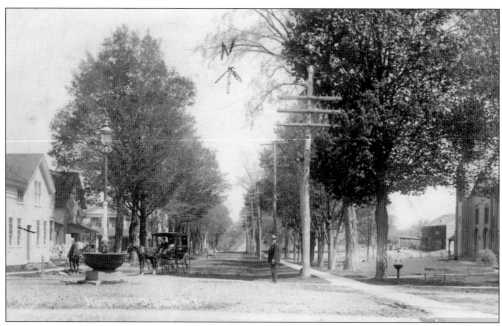

The phrase "Whoa, Nellie!" might have been heard as the pedestrians and wagon drivers approached the four corners of the village. They seem to be finding themselves about to be photographed for a picture postcard. (Courtesy of Dryden Town Historical Society.)

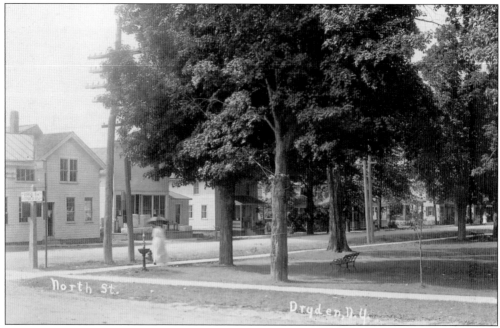

A dainty little lady is out for a stroll on North Street with her pretty parasol on a sunny day at the four corners. Directly across the street from the lady are a number of grave markers on display at the Dryden Monument Works. The building to its left was demolished to make way for Dryden's locally known "Gasoline Alley." (Courtesy of Dryden Town Historical Society.)

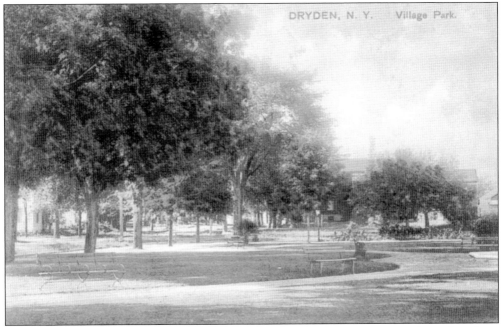

At the four corners of the village around 1905, in a view looking north across the park in front of Dryden's Presbyterian and Methodist churches, is a local display of trees, plants, and flowers planted for all to enjoy while strolling about or relaxing on one of the many park benches. (Author's collection.)

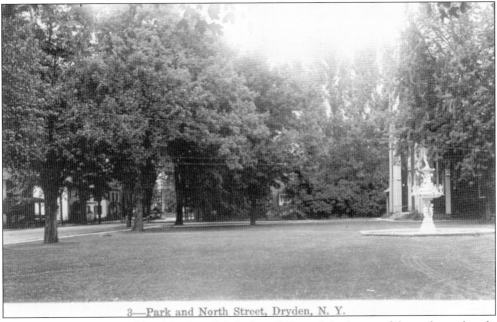

Things change, as attested by this view. It is before 1942, and the lawns of the park are sharply power-tractor mowed and trimmed. The original fountain in the center of the park was sold for scrap in 1942 to help fund the fight against the Axis forces of World War II. (Courtesy of Dryden Town Historical Society.)

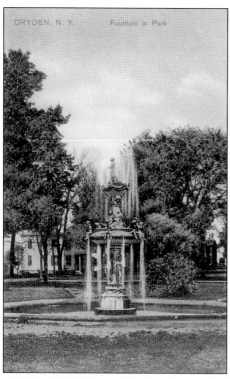

The beautiful water fountain in the village park can be seen in all its elegance on this card postmarked 1909. Its many cherubs play tunes to delight the passersbys, who listened as the lyrical sounds of the trickling waters delighted them with nature's delicate little ditties. (Courtesy of Dryden Town Historical Society.)

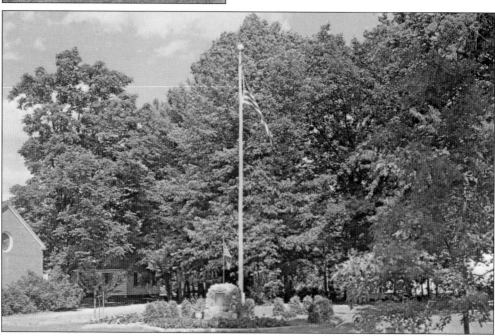

The beautiful bronze and cast-iron fountain was nothing but a sheer memory by 1962. Sold for scrap to help fund the fight against the Axis of World War II, the foundation became the home of a veterans memorial stone and the American flag and pole. Veterans conducted annual Memorial Day parades, ending ceremonies here at this stop. They would also gather briefly in commemoration of Veterans Day without any parade. (Author's collection.)

At the northern end of the village park in front of the Dryden Presbyterian Church, another commemorative stone can be found. An inscription reads, in part, as follows: "Edward Griswold, 1758–1843, a pioneer settler . . . donor of land . . . Village Green . . . Church . . . Cemetery . . . served in the revolution." (Author's collection.)

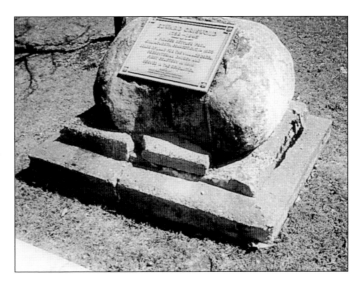

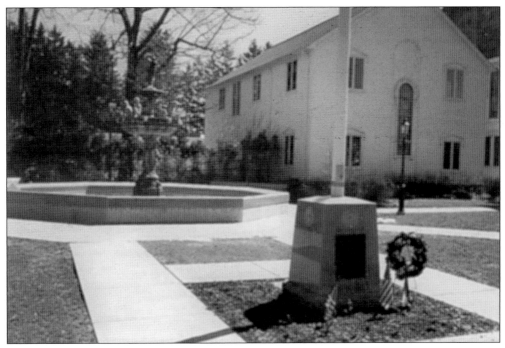

A new veterans memorial monument to the heroes of World War II replaced the original. A front plaque reads in part, "To honor those of the Town of Dryden who served their country . . . with the Allied Nations for World freedom." A second plaque, on the back side, tells of the monument's presentation during the 1997 Town Bicentennial Celebration. This is one of a series of images that are being made into picture postcards for distribution through the town historian's office. (Author's collection.)

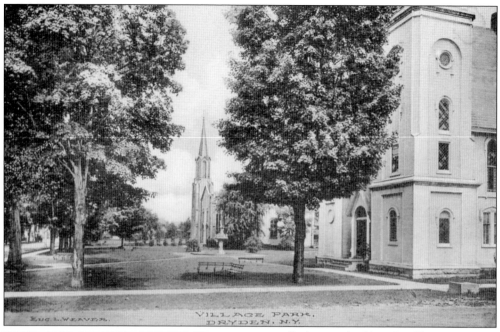

EUGL.WEAVER.

VILLAGE PARK,
DRYDEN, N.Y.

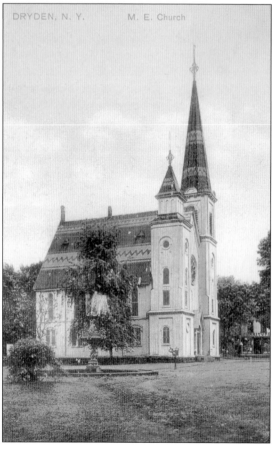

DRYDEN, N. Y. M. E. Church

Sitting on the historic village green, the Dryden Methodist Church has been an important landmark since its construction in 1832. It burned to the ground in June 1873 after renovations had just been completed. Some alterations and the addition of a connected Sunday school structure have been made over past decades. (Author's collection.)

Some refer to the Dryden Methodist Church structure as a wooden cathedral, though that is not the case. Here, it stands at the four corners as a historic landmark. The original structure burned to the ground in 1873, and it was immediately rebuilt and completed in 1875 as the magnificent edifice seen today. Recent additions of an attached building provided needed Sunday school rooms, offices, an assembly room, and a larger kitchen. (Courtesy of Dryden Town Historical Society.)

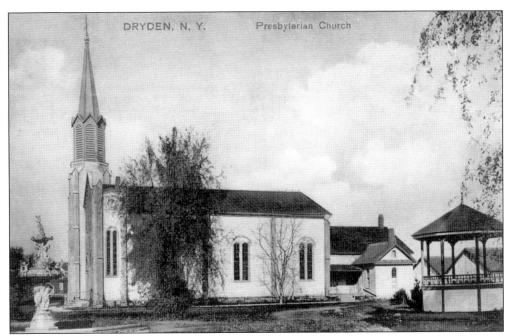

Like its neighboring church had earlier, the Dryden Presbyterian Church burned down in 1948. It, too, was rebuilt. Pictured in the foreground is the original bandstand; a similar one is now in the village's Montgomery Park. Another view of the original village park fountain is also pictured. (Courtesy of Dryden Town Historical Society.)

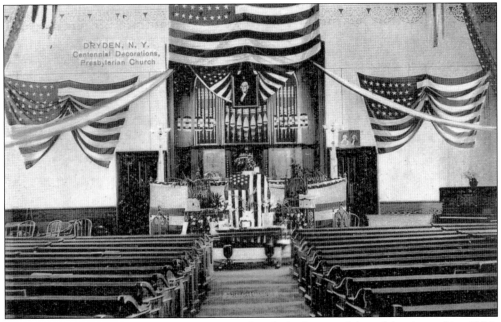

The sanctuary of the original Presbyterian church is decorated in celebration of its 100th anniversary, 1808–1908. The congregational pride of patriotism is overtly displayed throughout the interior of the sanctuary. (Author's collection.)

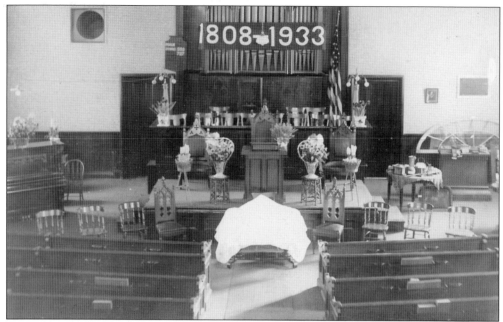

Work committees had been working diligently to ready the sanctuary of the Dryden Presbyterian Church for another anniversary, specifically its 125th anniversary year of 1933. In an effort to get copies made for public distribution, the photographer responsible for this postcard snapped the image a tad early, so the interior is in a state of unfinished disarray. (Author's collection.)

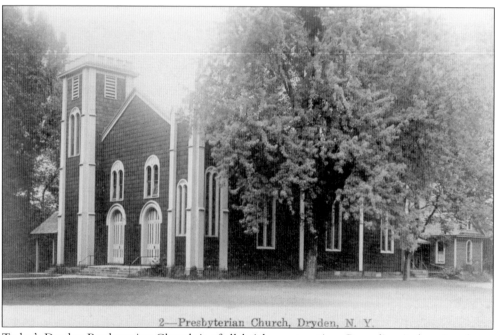

2—Presbyterian Church, Dryden, N. Y.

Today's Dryden Presbyterian Church is of all-brick construction. Preceding its burning down in 1948, the church stood in all its classical architectural grandeur and harmonious with its surroundings. (Author's collection.)

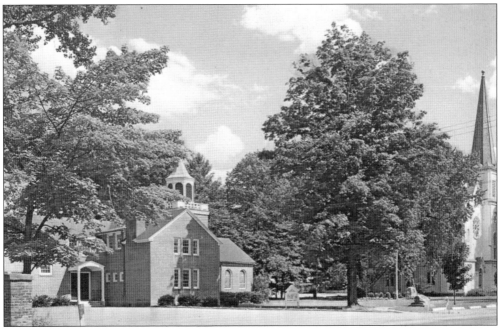

Dryden Presbyterian Church now stands next to the renamed Dryden United Methodist Church, and a portion of the village park is evident to its right. (Courtesy of Dryden Town Historical Society.)

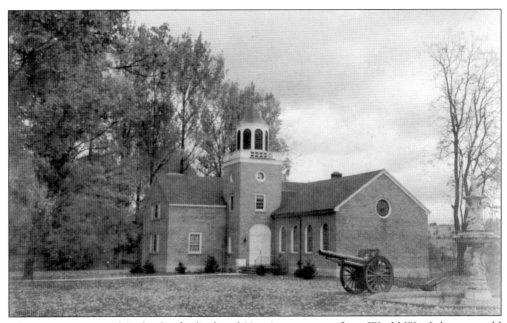

This is a rare postcard, indeed, of a displayed Howitzer cannon from World War I that was sold along with the bronze and cast-iron fountain for scrap in 1942 to aid in the funding of the Allies during World War II. (Courtesy of Dryden Town Historical Society.)

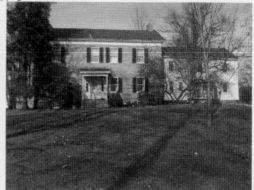

Photo by: Harry L.D. Weldon Jan. 3, 2005 Photo by: Harry L.D. Weldon Nov. 9, 2011

History House
36 West Main Street

Southworth Homestead House
14 North Street

This postcard (part of a onetime printing of only 50) depicts both places owned by the Dryden Town Historical Society. In 1984, the Dryden Town Historical Society acquired the mid-1800s house on West Main Street. In 2013, the Southworth Homestead and adjoining acres were bequeathed to the town's historical society. The sale of the original History House provided the needed funds to restore the bequeathed homestead to its former glory. (Author's collection.)

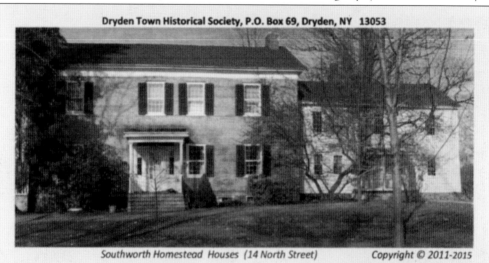

Southworth Homestead Houses (14 North Street) Copyright © 2011-2015

The Dryden Town Historical Society was bestowed the Southworth Homestead in 2013 with its two-acre lot, from an original farm tract of some 125 acres. The original section was built in 1836 of brick derived from on-site clay. Sometime before 1865, the wooden section, which is estimated to have been built around 1810, was moved from some undetermined site not too far from the four corners and attached to the east wall of the already standing brick house. (Author's collection.)

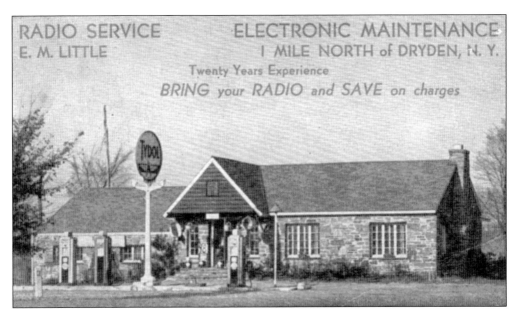

The Tydol gasoline service station has become a landmark. Ed Little was a local amateur radio operator who had the reputation of being able to fix just about anything electrical during his lifetime. The original building still stands today as Dedrick's Farm Market. (Courtesy of Dryden Town Historical Society.)

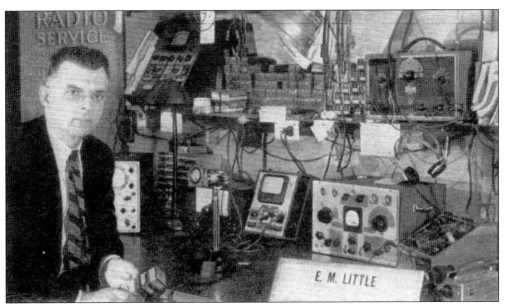

Seated at the controls of his amateur radio shack is Ed Little, who was also known as W2PHQ radio operator extraordinaire. For many years, he owned and operated the Tydol gasoline station and basket shop while living just north of the village of Dryden on the road to Cortland, New York. Today, his old place is now Dedrick's Farm Market. (Courtesy of Dryden Town Historical Society.)

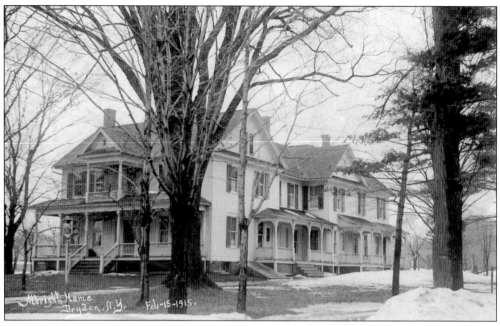

The Albright House, pictured in February 15, 1915, is remembered as a rest home for the elderly. Sadly, the beautiful structure no longer exists. This card is postmarked February 15, 1915. (Courtesy of Dryden Town Historical Society.)

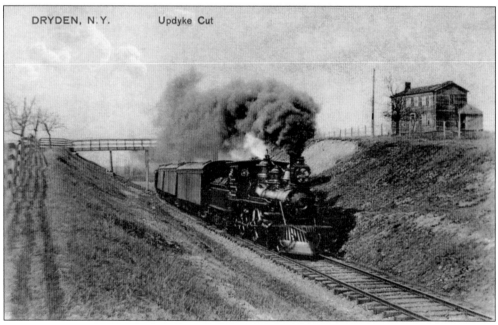

DRYDEN, N.Y. Updyke Cut

A Lehigh Valley Railroad steam train hauling milk is chugging through Updike Cut on its way to Freeville, long before the days of diesel. The refrigerated cars were loaded, in all likelihood, at the Borden Plant on South Street in the village of Dryden. (Courtesy of Dryden Town Historical Society.)

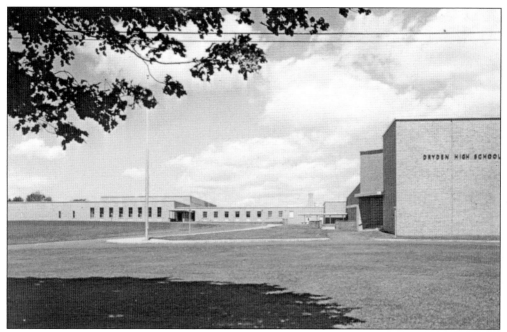

The more modern Dryden High School and its campus is proudly showcased by this postcard. This was only one of the many schoolhouses in the town of Dryden. Other schools in the district included Freeville, McLean, and James Street Elementary, Intermediate, and Middle Schools. (Author's collection.)

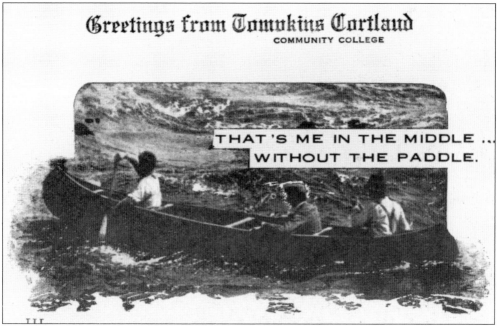

A humorous picture postcard, a rarity from the early founding days of Tompkins Cortland Community College in the 1960s, depicts a typical struggling student. The college population included students from many parts of New York State and other parts of the Northeast who studied varied disciplines. (Author's collection.)

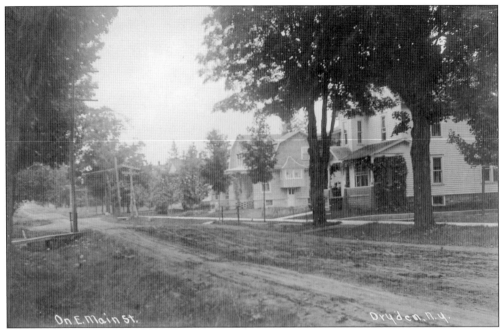

Some of the grand homes in the village of Dryden are pictured. This view along East Main Street before the road was paved faces toward Virgil, New York. (Author's collection.)

Pictured here are some of the more modest homes on East Main Street in the village of Dryden. This is another prime example showing the days before paved roads were common in the community. (Author's collection.)

Previously the residence of a former Dryden president back in the 1850s, this home is located on East Main Street in the village. The term *president* was used before the title *mayor*. The form of government in the village changed in 1865, thus creating the new mayoral office. (Courtesy of Dryden Town Historical Society.)

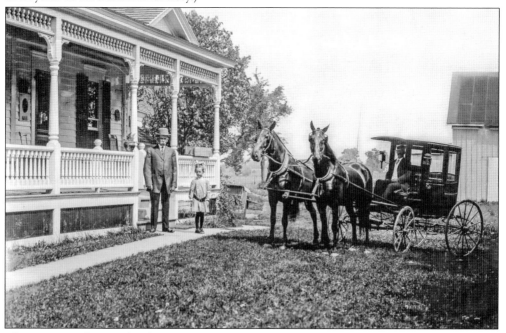

This is a typical example of photographs taken by Vern Morton, who generally opted to pose his clients for photo shoots. Family members would dress up all neat and trimmed. Clients would also bring out their prized possessions, such as this sedan buggy and stately team of horses. (Courtesy of Dryden Town Historical Society.)

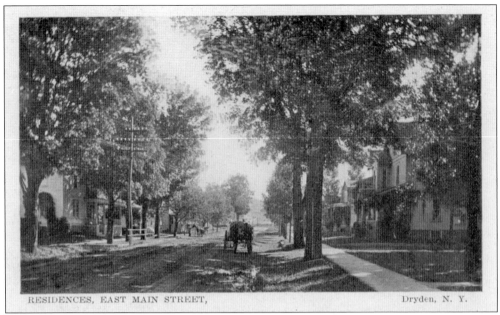

RESIDENCES, EAST MAIN STREET, Dryden, N. Y.

Luscious shade trees lend nicely to making this view of East Main Street depict a good place to live. Those living there attest to this, even to this day. (Courtesy of Dryden Town Historical Society.)

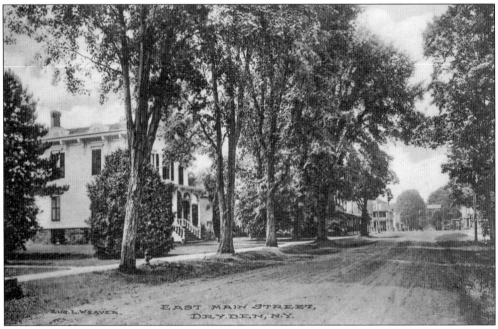

EAST MAIN STREET, DRYDEN, N.Y.

Well-tended homes and groomed lawns and walkways show the pride of ownership the residents on East Main Street had in their properties. The main house featured is the mansion of Jerimiah Dwight, who was a former legislator in the US House of Representatives. (Author's collection.)

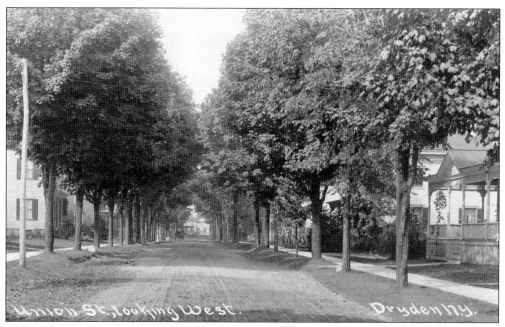

In this view looking west on Union Street in the village, a picturesque tunnel of bountiful trees can be seen. (Courtesy of Dryden Town Historical Society.)

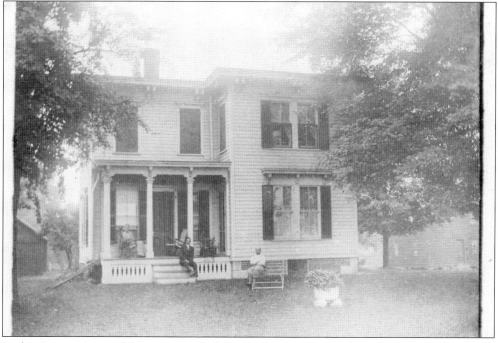

In this "vanity postcard," an unidentified family sits proudly posed on the front porch while a photographer snaps this portrait. (Courtesy of Dryden Town Historical Society.)

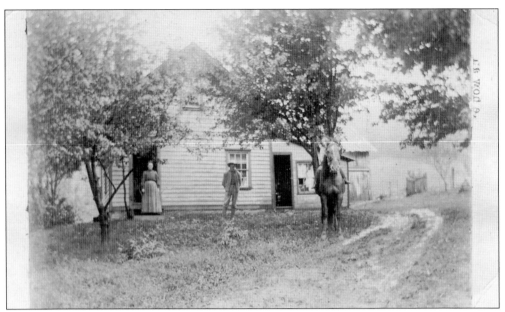

This unidentified couple humbly poses with their daughter astride the family's draft horse in the village of Dryden. (Courtesy of Dryden Town Historical Society.)

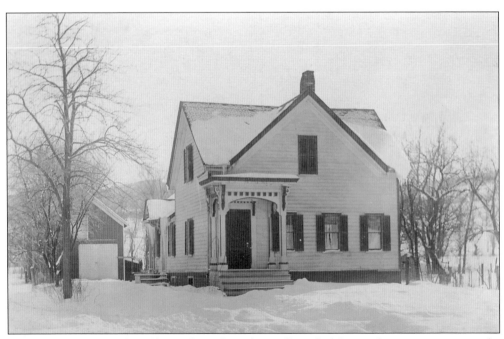

On a wintry day in the village of Dryden, this well-crafted home thrusts out to meet the elements with a cheerful welcome. (Courtesy of Dryden Town Historical Society.)

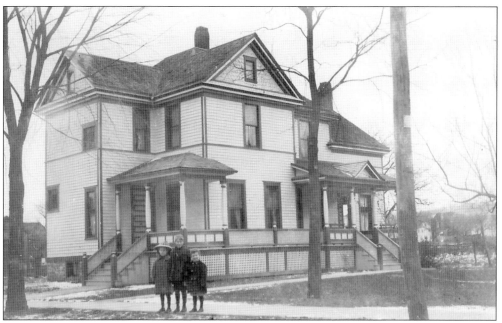

On a chilly day, three little ones stand along the sidewalk posing with smiling faces. (Courtesy of Dryden Town Historical Society.)

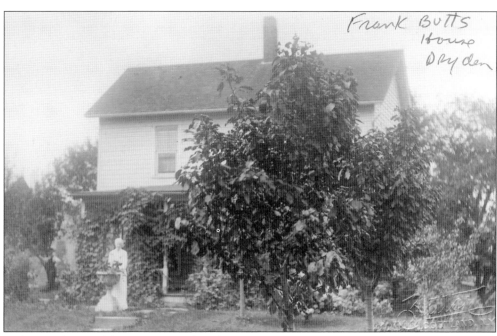

Although the scribbled note states that this view shows the home of Frank Butts, there is no further commentary. Noteworthy, though, is the woman standing in front of a raised planter surrounded by a bloom-shrouded porch. The photographer has captured this home gardener smiling with pride in her garden. (Courtesy of Dryden Town Historical Society.)

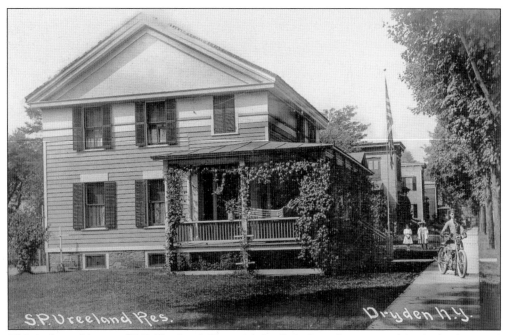

This is the residence of S.P. Vreeland. Two girls in their finer dresses stand in the background behind a spiffed-up lad with his motorcycle. This was likely a planned photograph to showcase Dryden in an all-American scene. (Courtesy of Dryden Town Historical Society.)

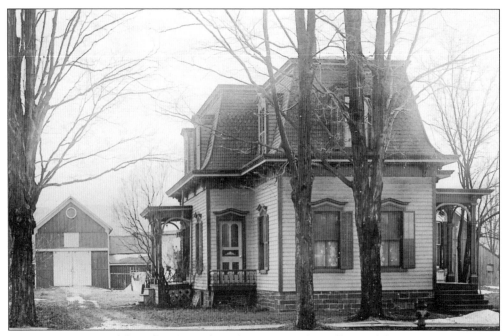

In various sections of the village's residential area, a number of beautiful Victorian homes can be found still standing. This house graced the hearts of its original owners and is beloved by the current owners. (Courtesy of Dryden Town Historical Society.)

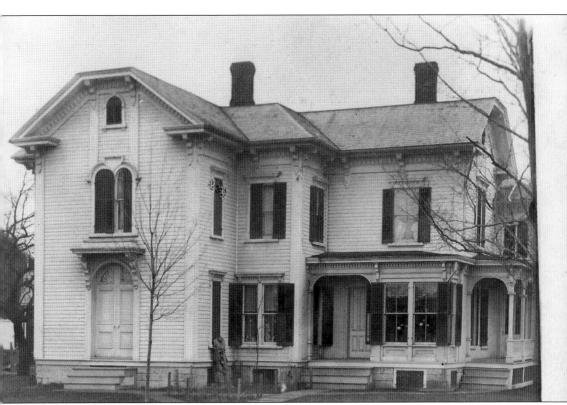

Among the many old homes in the village of Dryden, this residence includes some of the more unique architectural concepts that are found within the village. (Courtesy of Dryden Town Historical Society.)

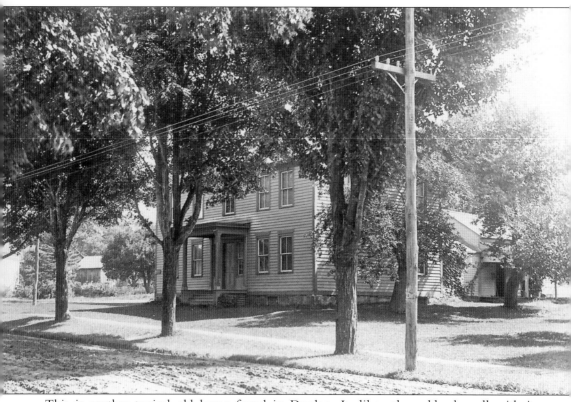

This is another typical old home found in Dryden. It, like others, blends well with its surroundings. This image was taken before paved streets were the norm. (Courtesy of Dryden Town Historical Society.)

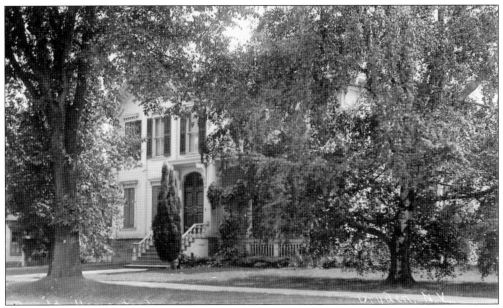

Nestled in the heart of the village within 300 feet of the infamous four corners of Dryden, among the now lost elm trees, lies the Dwight Homestead Mansion. It has since been sold out of the Dwight family but remains a private home. Still standing, though, are the various outbuildings, including a carriage house, a granary, a woodshed, an icehouse, and an outhouse. (Courtesy of Dryden Town Historical Society.)

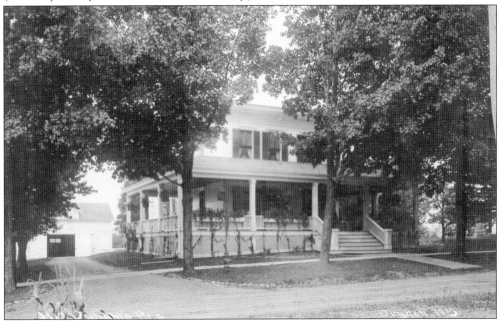

Another view of Jeremiah W. Dwight's homestead captures the carriage house in the background. J.W. Dwight was a congressman in the US House of Representatives from 1877 to 1883. His son, John W. Dwight, also served in the House of Representatives, from 1902 to 1913. The Dwight family was locally instrumental in the Dryden Agricultural Society Fair and invested in farmlands in the Dakota Territory. (Courtesy of Dryden Town Historical Society.)

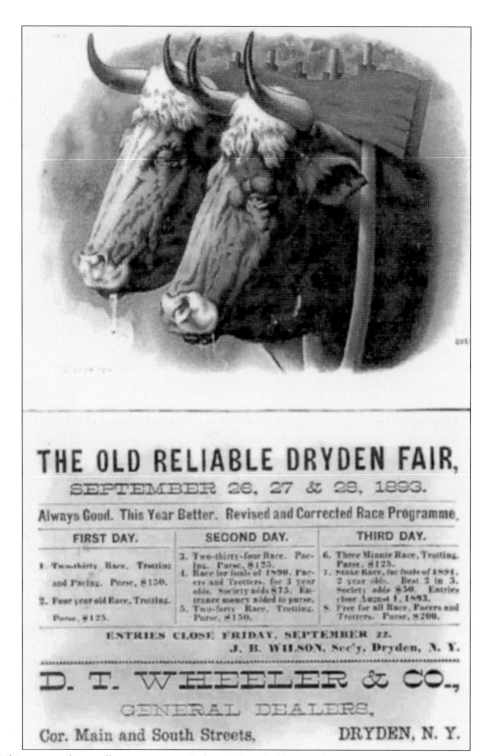

This postcard proudly announces, "The Old Reliable Dryden Fair is coming to town on September 26, 27 & 28, 1893." Attendees joined others from all over for this festive activity. (Author's collection.)

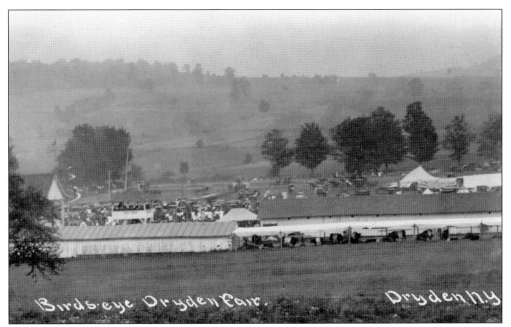

This very rare postcard features a bird's-eye view of the Dryden Agricultural Society Fair, promoted in its day as second only to the Great New York State Fair. The last fair held here ended with the 1918 season. A low-altitude flight today over the area delineates what is left of the racetrack and the markings of long-ago building foundations. (Courtesy of Dryden Town Historical Society.)

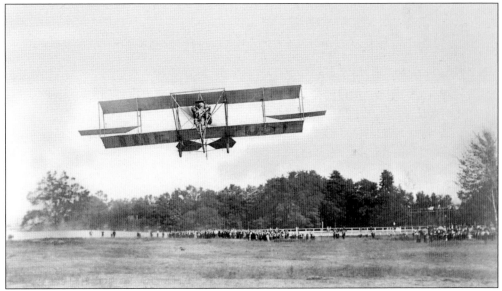

In the early days of aviation, "Up and away with me, Lucille, in my flying machine" might have been what fairgoers heard as this early Wright Flyer took to the sky in 1908, five years after the Wright brothers' historic flight in Kitty Hawk, North Carolina. One resident, Paul Wilson, was inspired by this flight to become a test pilot for the Thomas-Morse Aircraft Company in nearby Ithaca, New York. There, Scout Trainer aircraft were tested for the US Army Air Corps in 1917. (Courtesy Dryden Town Historical Society.)

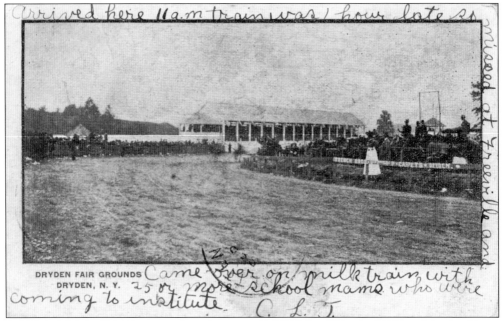

Arrived here 11 a.m train was 1 hour late so missed at Freeville and

DRYDEN FAIR GROUNDS
DRYDEN, N. Y.

Came over on milk train with 25 or more school mams who were coming to institute. C. L. J.

This is the only such image of the racetrack and grandstand at the Dryden Agricultural Society Fair. The fair was first organized in the late 1800s, and its last season was in 1918, marking the end of the Dryden Agricultural Society. Much of the former property is now the environs of the current town hall and highway maintenance buildings. (Courtesy of Dryden Town Historical Society.)

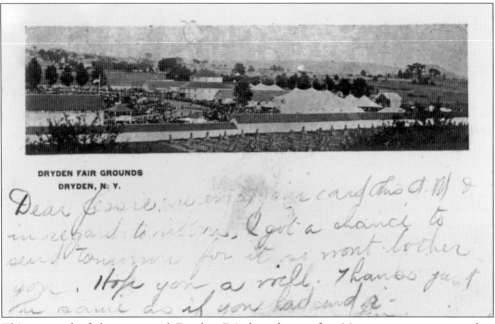

DRYDEN FAIR GROUNDS
DRYDEN, N. Y.

This postcard of the renowned Dryden Fair has plenty of writing space to accommodate the sender—although 100 years later, the writing is mostly illegible to the reader. (Author's collection.)

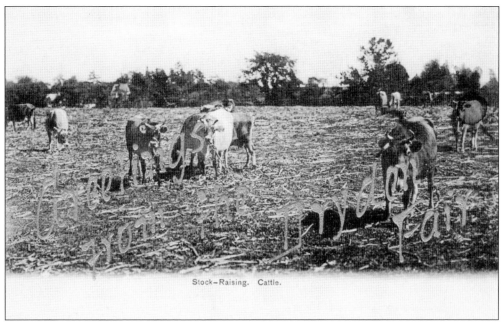

Stock-Raising. Cattle.

Cattle are pictured grazing in a harvested field of leftover grain. The clever budget-saving tactic of repurposing a postcard for a souvenir has been artistically implemented here by writing with glue and sprinkling with powder the words "Greetings from the Dryden Fair." (Courtesy of Dryden Town Historical Society.)

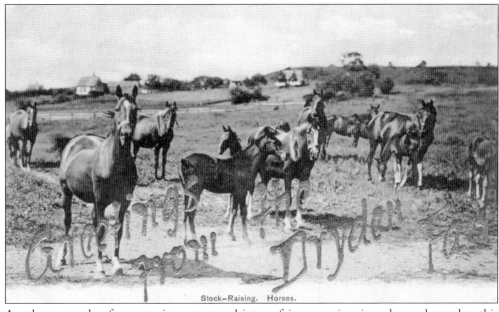

Stock-Raising. Horses.

Another example of repurposing a postcard into a fair souvenir using glue and powder, this card shows a herd of horses standing in a field, mesmerized by the photographer. (Courtesy of Dryden Town Historical Society.)

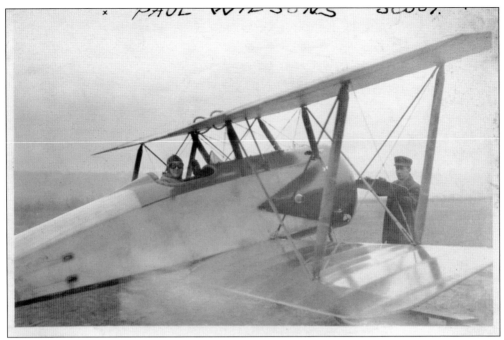

Paul Wilson sits ready at the controls of a biplane in the 1920s. He is smiling as an assistant prepares to spin the propeller for a start-up. Wilson was a senior test pilot for the Thomas-Morse Aircraft Company in Ithaca, New York. The company built trainer planes for aspiring military pilots during World War I. Wilson was always fascinated with speed and flight, often racing cars at the Dryden Agricultural Society Fair, and is reputed to have landed and taken off from the inner fair track in this type of airplane while demonstrating daredevil aeronautical stunts in the skies above Dryden. (Courtesy of Dryden Town Historical Society.)

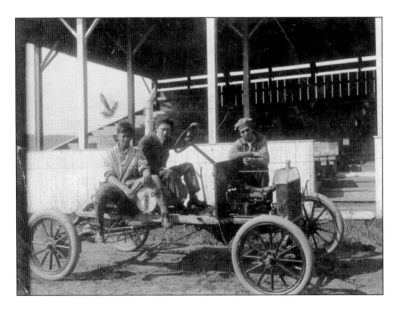

Pictured in front of the grandstand is one of the stripped-down Ford Model T automobiles that Paul Wilson is reputed to have used as a racer at the Dryden Agricultural Society Fair. The arrow points to a young, unidentified racing team member, believed to be pictured sometime around 1915. (Courtesy of Dryden Town Historical Society.)

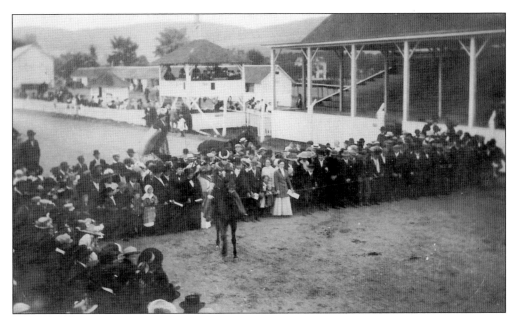

At the 1915 Dryden Agricultural Society Fair, equestrienne performers were always popular favorites. Shown here is an unidentified lady rider putting her mount through its paces while a pleased crowd watches in amazement as the horse skillfully completes its routine. (Courtesy of Dryden Town Historical Society.)

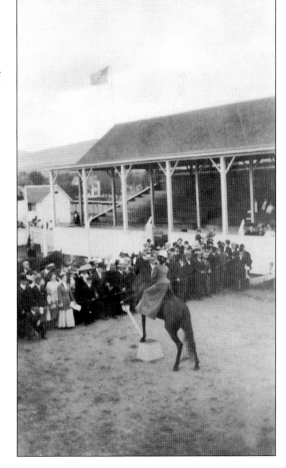

The same unidentified lady rider has her horse at the peak of a routine trick, as only the two rear hooves are seen touching the ground while the front hooves are resting on an apparatus of some sort. The lady has her mount in total control; her picturesque posture would please any equestrian judge. (Courtesy of Dryden Town Historical Society.)

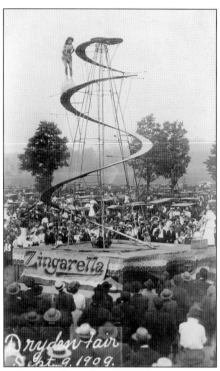

Some outstanding performers were featured at the Dryden Agricultural Society Fair. One of them was Zingarella, who, on September 9, 1909, was a featured daredevil performer from Coney Island Amusement Park. She would stand on a rubber ball and walk it up the spiral inclined plane by stepping backwards on it. Upon reaching the top, she would take a bow and then walk it back down backwards, to the thrill of the gathered audience. (Courtesy of Dryden Town Historical Society.)

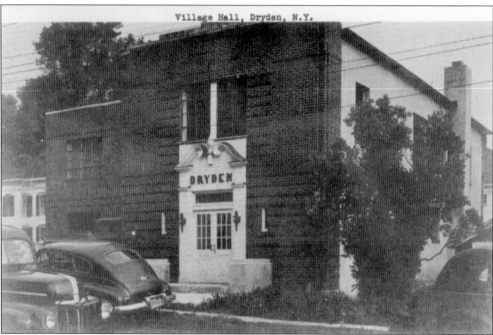

This little-known postcard from the late 1940s shows the Dryden Village Hall entrance at the corner of South and George Streets. The Dryden Fire Department was housed in the three truck bays facing South Street. The top floor was open for public meetings, while the village office and board room were behind the stairs that led to the upstairs. (Courtesy of Dryden Town Historical Society.)

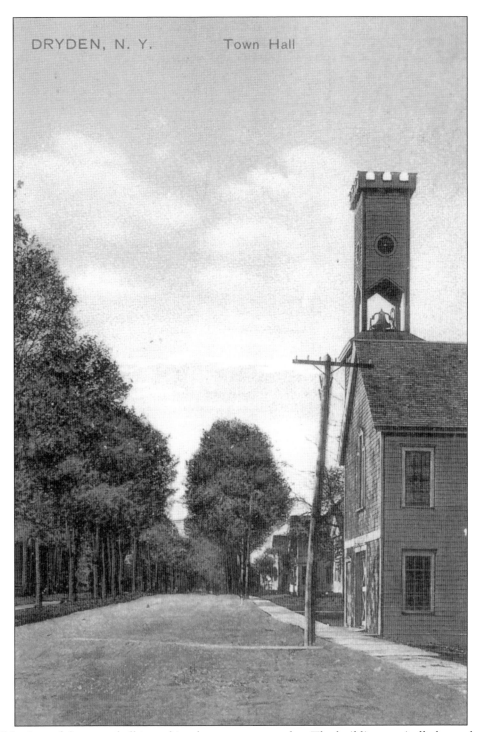

DRYDEN, N. Y. Town Hall

This view of the town hall is nothing but a memory today. The building tragically burned to the ground and was reconstructed as the Dryden Village Hall. It was shared by agreement and also housed the fire department and its equipment in the earlier days. (Courtesy of Dryden Town Historical Society.)

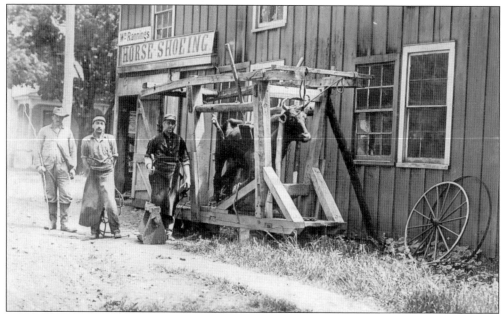

Horses and oxen were the mode of travel before the automobile. Seen here is William Rannings, a blacksmith and farrier. Alongside the building was the farrier setup. This business was located next to the former town hall on South Street. When the elevator was installed during the modernization of the current Dryden Village Hall, a number of discarded oxshoes were found among the buried remains. (Courtesy of Dryden Town Historical Society.)

Fantasized fireworks appear over an anniversary celebration at the Bailey Insurance Company on South Street. The black sky, rosette whirls, and the huge full moon were artistically added to create a celebratory illusion. (Courtesy of Dryden Town Historical Society.)

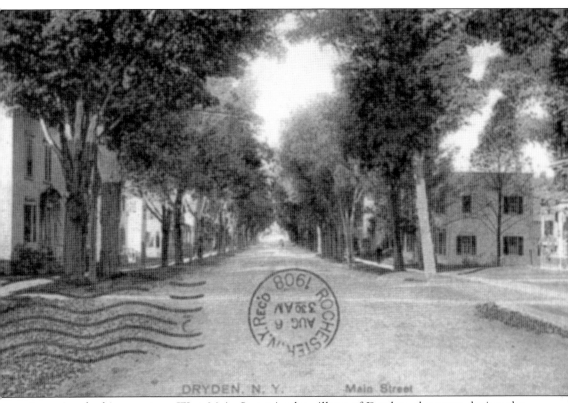

In a view looking west on West Main Street in the village of Dryden, the scene depicts the tranquility of the village. Note the Rochester postmark dated August 6, 1908, on the face of the postcard. (Author's collection.)

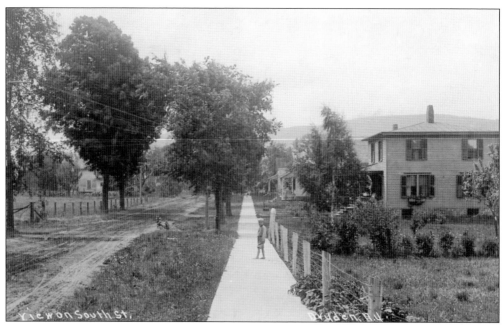

When regarding this view looking down South Street toward Dryden Lake, one can appreciate the paved roads of today. This photograph was taken around 1895. The young lad is barefoot, with high grass and giant weeds growing almost into the middle of the dirt road. (Author's collection.)

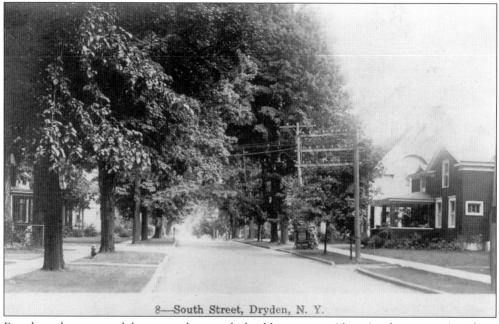

8—South Street, Dryden, N. Y.

Paved roads, groomed lawns, and pruned shrubbery are evident in the properties along South Street by the 1930s. Fire hydrants are installed throughout the village. Traveling and tourism had started to boom, by the looks of the curbside sign. (Courtesy of Dryden Town Historical Society.)

This illustrated postcard shows a little girl speaking to her mother on the telephone. (Author's collection.)

COPYRIGHT 1906 ULLMAN MFG. CO. N. Y.

"HELLO, MAMA!"

1727

These three young ladies are posing very properly in their finest dresses on South Street. (Courtesy of Dryden Town Historical Society.)

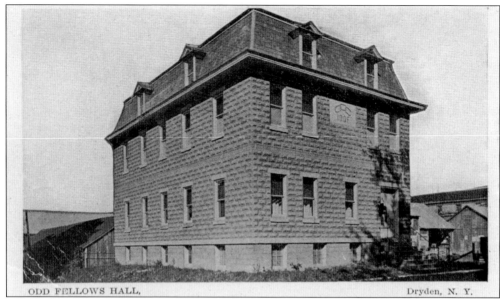

ODD FELLOWS HALL, Dryden, N. Y.

The Dryden Independent Order of Odd Fellows No. 390 called this building its home for many years, as did the Dryden Rebekah Lodge. In recent years, due to declining membership, the two lodges folded. During their collapse, the Dryden Lodge No. 472, Free and Accepted Masons, who had been renting part of the building, continued to hold their meetings there. The Masons met the same declining membership problems but were successful in merging and moving to Groton to form a new lodge with the Groton and Lansing Masons, establishing the Tri-Town No. 472 Free and Accepted Masons. (Author's collection.)

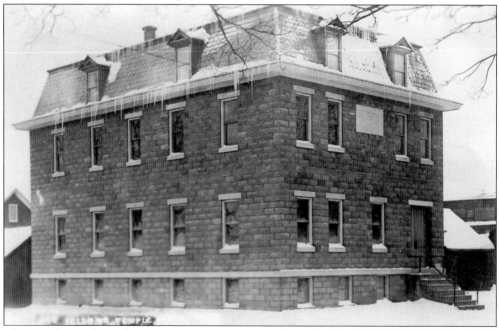

The Dryden Independent Order of Odd Fellows No. 390 building is shown on a cold winter's day in the 1920s, shrouded with ice about its eaves. (Courtesy of Dryden Town Historical Society.)

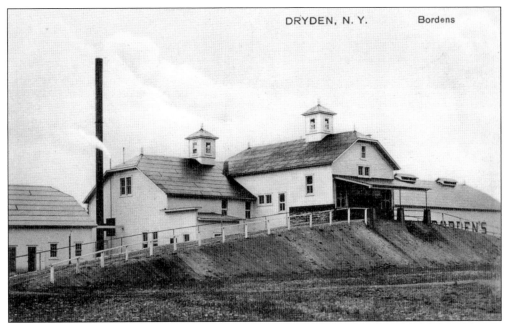

The premier Borden's Milk Plant on South Street in the 1930s was a major stop for the milk trains of the Lehigh Valley Railroad system. Trains could load blocks of ice into their milk cars at the Dryden Lake Ice Plant, pick up the processed milk at Borden's, then transport it to the New York City market. Today, the railroad has since been scrapped and the building repurposed to house the Dryden Village Department of Public Works. (Author's collection.)

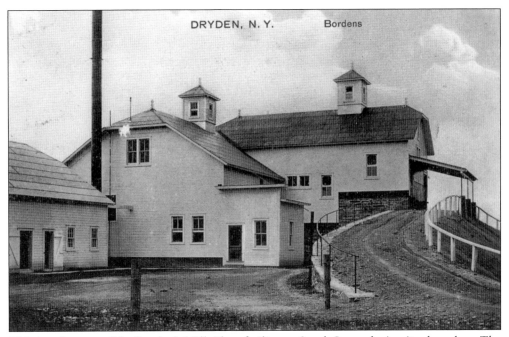

This is a close-up of the Borden's Milk Plant facility on South Street during its glory days. The dirt incline led to the beginning of the cascade of connecting buildings. (Author's collection.)

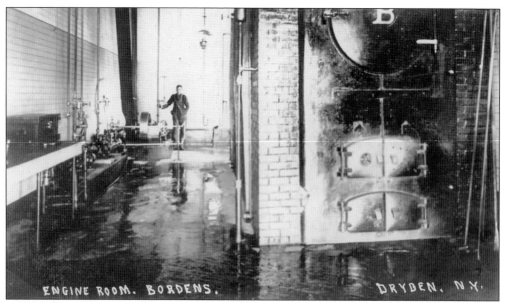

An employee poses for a picture postcard in the interior of the boiler room at the Borden's Milk Plant on South Street. Before the plant's closure, the boiler room was the epicenter of all the milk-processing operations. (Courtesy of Dryden Town Historical Society.)

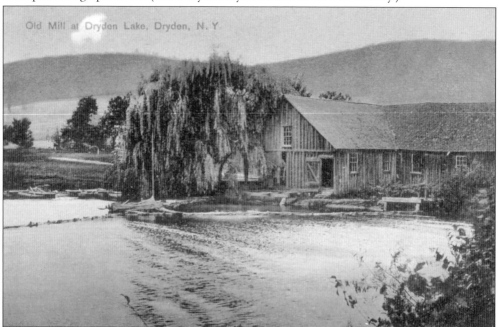

The old sawmill and dam at Dryden Lake are pictured before the 20th-century technology that led to its abandonment. The dam raised the six-foot-deep glacial kettle lake up to its present depth of ten feet. The lake and dam are managed today by the New York State Department of Environmental Conservation. The lake is a favorite fishing spot in all seasons for panfish and bass. On the northern end of the lake is a former campground used by Native Americans before the arrival of Dryden's first settler in 1797. Now no longer discernable, the campground has been eradicated to make way for a modern housing development. (Author's collection.)

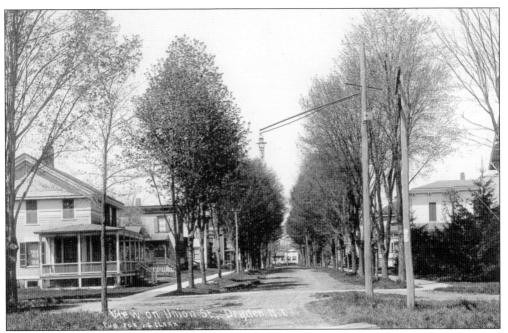

Pictured on Union Street in the village of Dryden, before modern-day paved roads, the old gas streetlight is a reminder of how far technology has come. (Author's collection.)

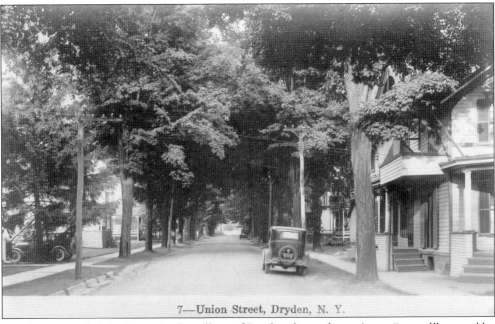

7—Union Street, Dryden, N. Y.

Another view of Union Street in the village of Dryden shows the ominous "tunnel" created by all the trees leading to the present-day elementary school. Vintage cars by today's standard are parked along the paved street. (Courtesy of Dryden Town Historical Society.)

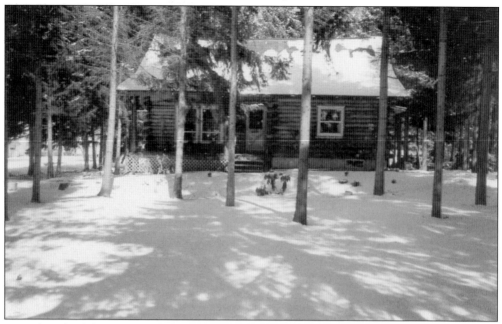

A modern-built log home with all the standard amenities sits in a wooded section on James Street. It was built just before the beginning of the 21st century. It was used as a bed-and-breakfast for a while but is now a private residence. Not too far from this location is the reputed site of the first settler's log cabin, built in 1797 by Amos Sweet. (Courtesy of Dryden Town Historical Society.)

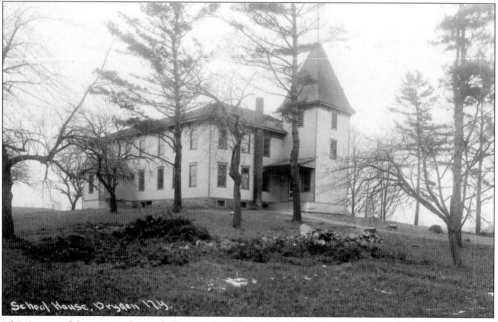

This is one of the original wood-frame schoolhouses built within the village off of James Street. Other such schoolhouses were scattered throughout the village. The very first schoolhouse in the village of Dryden was Amos Sweet's converted log cabin that was abandoned in 1803 by Sweet's family. (Courtesy of Dryden Town Historical Society.)

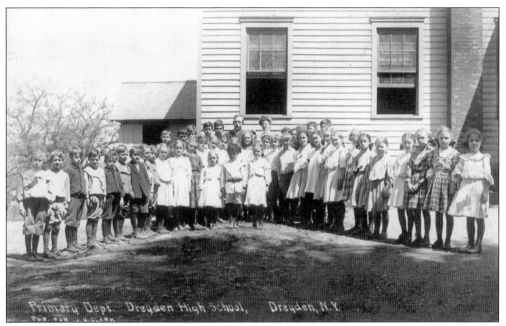

These young students are posing in their school clothes in one of the earlier wood-frame schoolhouses in the Dryden Primary Department. (Courtesy of Dryden Town Historical Society.)

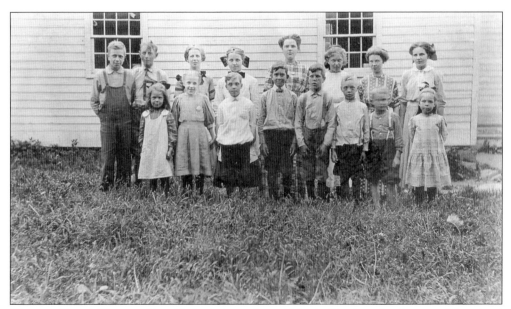

These smiling children are identified as being a class within the Dryden school system. The school building is likely a rural schoolhouse, as noted by the small class size and simple architecture —unlike those seen within the village. (Courtesy of Dryden Town Historical Society.)

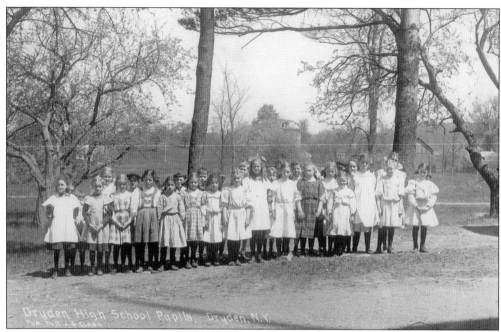

Captioned as a class of "Dryden High School Pupils," this photograph shows a group standing tall among the towering trees; however, the students do not appear to be of high school age. Their appearance is more like that of children of elementary school age. (Courtesy of Dryden Town Historical Society.)

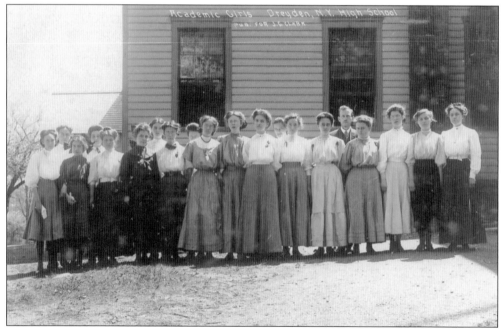

A class of academic girls in the Dryden High School stands with a male teacher. These girls appear to be high school aged. (Courtesy of Dryden Town Historical Society.)

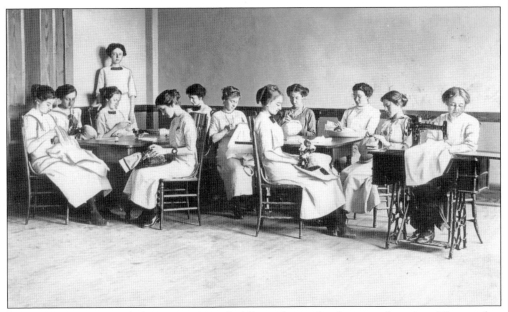

These young, demure ladies are sitting placidly to learn the fine art of sewing. The teacher overseeing them in the background also taught a cooking class. (Courtesy of Dryden Town Historical Society.)

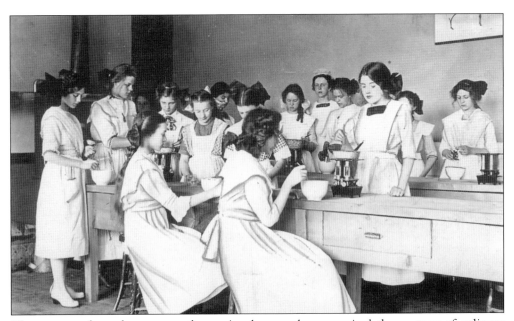

The same teacher who oversaw the sewing lessons also supervised the mastery of culinary skills. By today's educational standards, the domestic skills of sewing and cooking do not have the importance they once had, due to the innovations of things such as frozen foods and microwaves and the convenience of mail-order and online shopping. (Courtesy of Dryden Town Historical Society.)

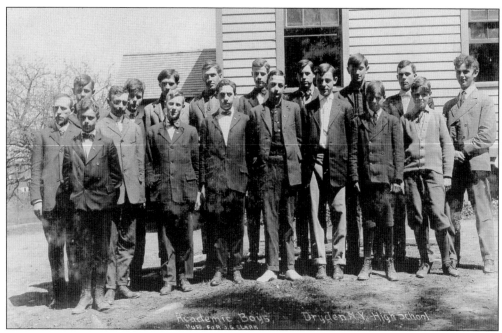

A class of debonair academic boys from the Dryden High School, dressed in their finer garments, stands dapperly in front of the schoolhouse. (Author's collection.)

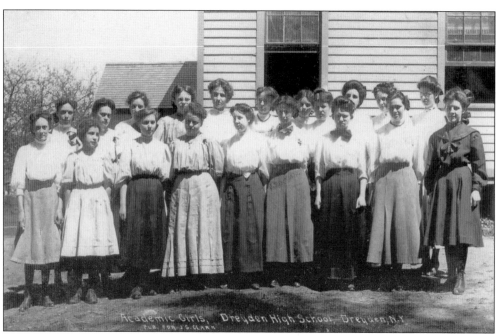

Another class of academic girls in the Dryden High School stands stately in front of the same schoolhouse. (Courtesy of Dryden Town Historical Society.)

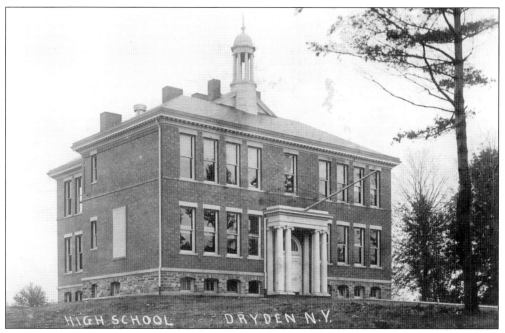

This view of the Dryden High School is that of a building that once housed students in grades kindergarten through 12th grade. Later, it formed one of the core wings of the present-day elementary school located on James Street. (Courtesy of Dryden Town Historical Society.)

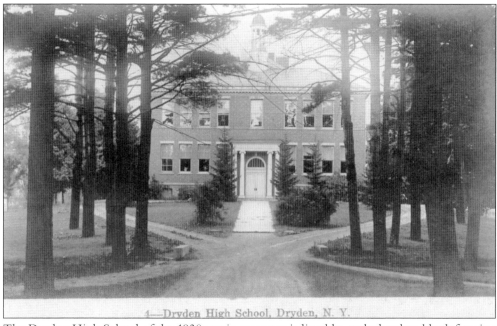

The Dryden High School of the 1930s main entrance is lined by paths bordered by lofty pine trees. Although it states that it is solely the high school, it was actually the schoolhouse that accommodated all the grades, from kindergarten up to twelfth grade. (Author's collection.)

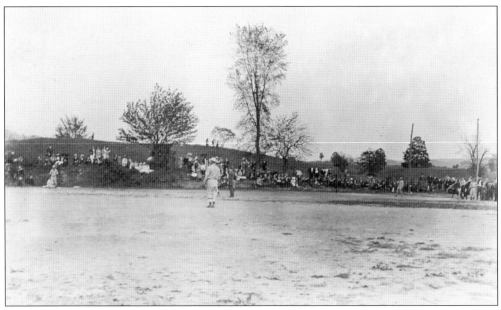

Spectators line the field to watch the ball game. While it is unknown whether this was a championship game or just an exhibition game, it sure did draw a large crowd. (Courtesy of Dryden Town Historical Society.)

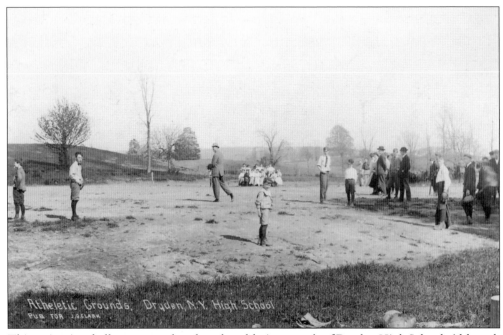

This springtime ball game was played on the athletic grounds of Dryden High School. Although the occasion cannot be verified, the numerous spectators lead viewers to use their imaginations as to why the young boys are playing baseball with so many onlookers. (Courtesy of Dryden Town Historical Society.)

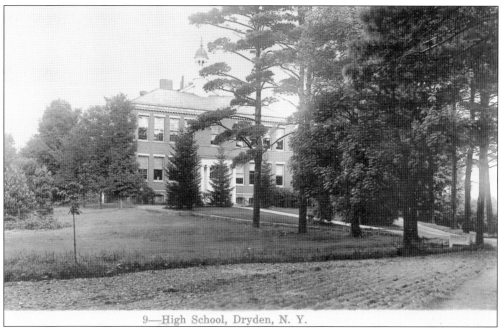

9—High School, Dryden, N. Y.

This is a sweet summertime view of the Dryden High School campus as seen from the freshly sprayed James Street dirt roadway. No students can be found on the campus during this time, as they are out and about enjoying their annual summer vacation. (Courtesy of Dryden Town Historical Society.)

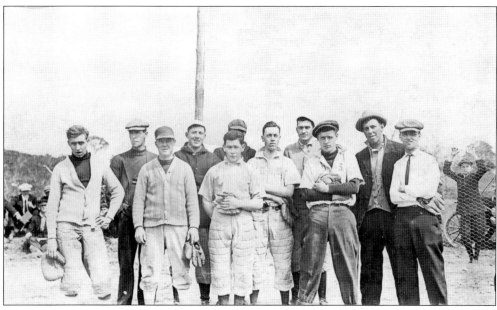

The Dryden Town baseball team seems to begrudgingly stand for a picture. Several of the players look like they just want to get on with their game. (Author's collection.)

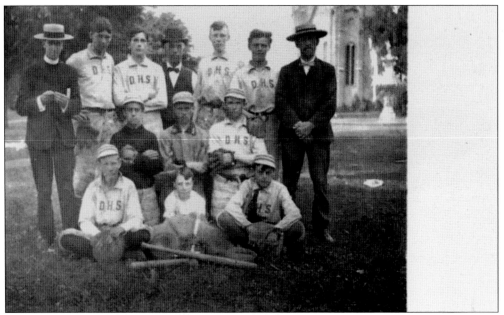

Members of the Dryden High School baseball team sit impatiently while their picture is taken. The image was taken on the village green with their coach and a local pastor sometime in the 1920s. (Courtesy of Dryden Town Historical Society.)

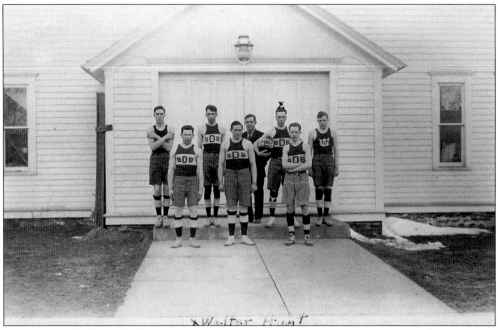

In days gone by, basketball games were played in the Dryden Opera House on Library Street. The rest of the players stand with their teammate Walter Hunt, who is singled out with an inked "X" over his head, put there by the sender of this postcard. (Courtesy of Dryden Town Historical Society.)

The Dryden Opera House on Library Street served the village community with a variety of entertainment during its tenure. Theatrical plays, program presentations, high school and town basketball games, high school graduation ceremonies, and addresses by political candidates were among the many activities that took place within its walls. In the mid-20th century, the venue was remodeled into an apartment building. (Courtesy of Dryden Town Historical Society.)

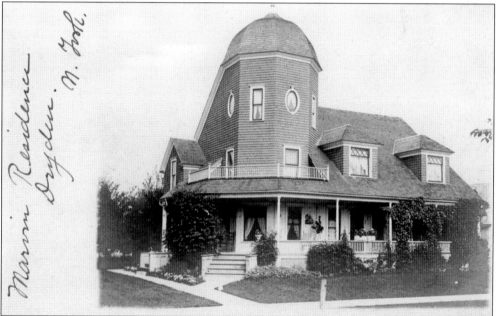

The note scrawled on the left of this postcard identifies this beautiful building as the Marvin residence. At one point in time, it was just that; however, it has changed ownership multiple times over the years. Recently, it was used as a bed-and-breakfast for a short time. This postcard depicts a unique architectural concept of Italianate design. (Courtesy of Dryden Town Historical Society.)

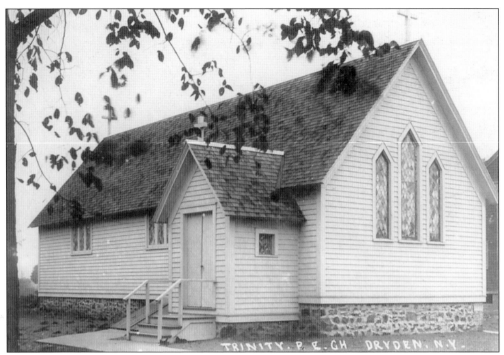

Located on Library Street, this structure was built as the Trinity Protestant Episcopal Church. It only had a small congregation of faithful followers and was deconsecrated prior to 1950. Afterwards, the building was used for a time as a funeral chapel. Currently, it stands as a habitable dwelling. (Courtesy of Dryden Town Historical Society.)

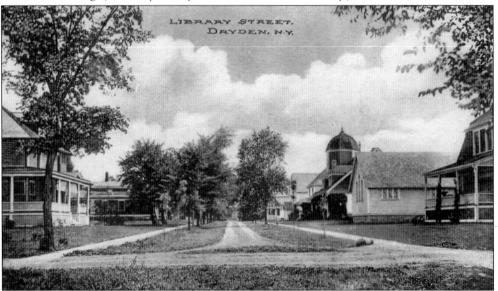

In a view looking back up Library Street toward West Main Street, the Trinity Episcopal Church, an Italianate home, and, farther up, the Dryden Opera House stand along the tree-lined dirt road. Few changes have been made to Library Street over the years; it looks very similar to the image in this postcard but with the added modern convenience of a paved street. (Author's collection.)

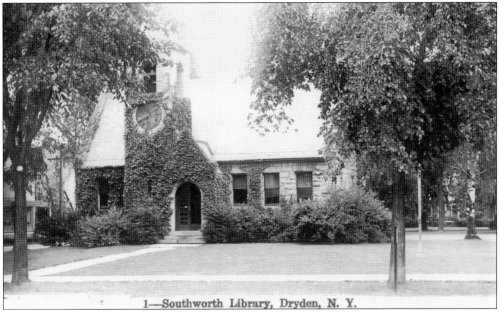

1—Southworth Library, Dryden, N. Y.

The Southworth Library sits proudly decked in ivy at the corner address of 24 West Main Street. Jennie McGraw Fiske gifted the library to the Dryden community in honor of her mother, Rhoda Southworth McGraw, and grandfather John Southworth, who built two key buildings near the four corners of Dryden. This Romanesque Revival library includes a bell tower and two main reading rooms. The more recent Lincoln Center addition was made possible through the sale of Abraham Lincoln's original 1864 reelection speech. (Author's collection.)

This image of an unidentified woman stoically posing behind the wheel of an automobile provides many questions for future generations to ponder. (Courtesy of Dryden Town Historical Society.)

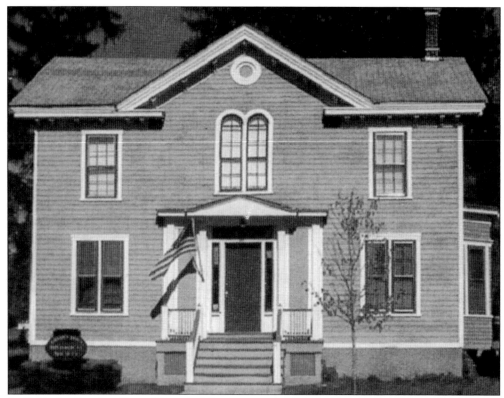

In 1984, the Dryden Town Historical Society acquired the mid-1800s house at 36 West Main Street. Then, in 2013, the society was bequeathed the Southworth Homestead and adjoining land at 14 North Street. The property on West Main Street has since been sold to provide funds to restore the North Street homestead, where the society is now headquartered. The homestead is now the home of the society's museum-quality displays of varied collections and an office-resource library. Tours of the homestead are offered. (Author's collection.)

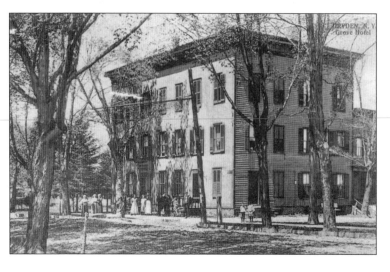

A view of the Dryden Hotel on West Main Street shows a gathering taking place. The signature manner of posing was to have people stand in their Sunday best and meticulously frame and focus each picture. (Author's collection.)

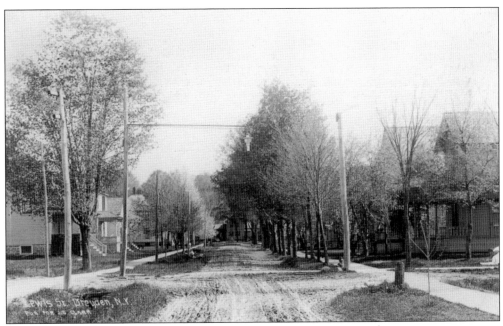

All is well here on Lewis Street in this tranquil scene from 1912. There are hard sidewalk surfaces, but unpaved dirt roads are still the norm. (Courtesy of Dryden Town Historical Society.)

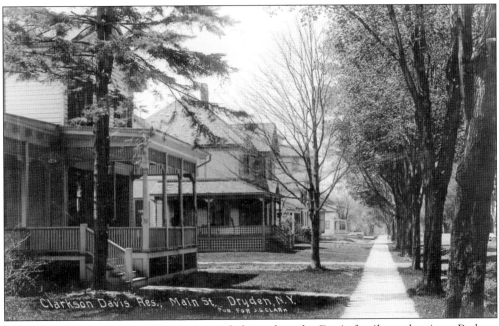

This Victorian-era house on Main Street belonged to the Davis family at the time. Perhaps the recent installation of a plank sidewalk by the village provided the family with a reason to have a picture made of their home before the wood turned to a weathered charcoal gray hue. (Courtesy of Dryden Town Historical Society.)

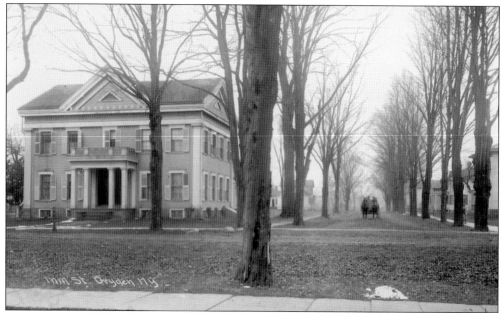

The Lacy–Van Vleet House is located at the corner of East Main and Mill Streets. The house became the property of John C. Lacy in 1863 and originally included an orchard. It is of traditional Georgian design with Greek Revival elements. Iron hitching posts and rider step blocks can still be found around the house and its carriage house barn. It is now the Candlelight Bed and Breakfast, and the current proprietors offer many amenities, including traditional afternoon tea parties. (Courtesy of Dryden Town Historical Society.)

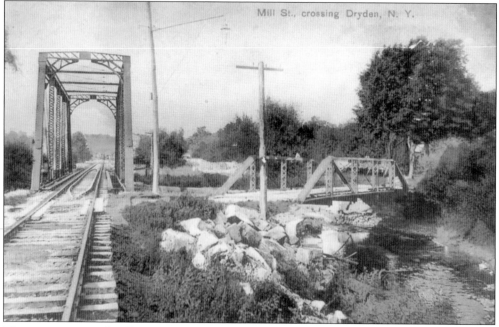

The convergence of Mill Street, Virgil Creek, and the Lehigh Valley Railroad tracks running across a bridge provides an interesting layered effect for this 1890 picture postcard. (Courtesy of Dryden Town Historical Society.)

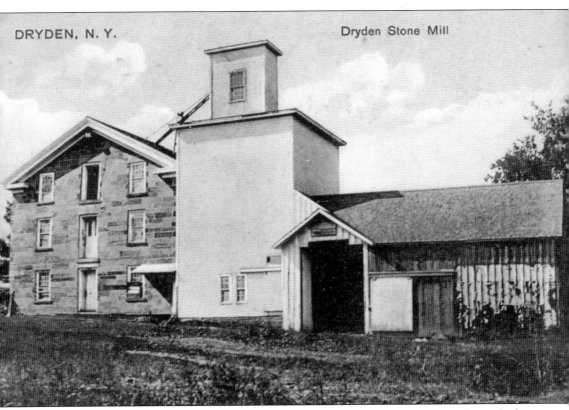

A section of Mill Street was home to the Dryden Stone Mill. The mill was situated alongside the Dryden Lake Outlet Creek that feeds into Virgil Creek. After the mill closed, it was completely demolished. The salvaged stones found their way all over the town, being repurposed as foundations, stepping stones, fences, and in many other useful ways. (Author's collection.)

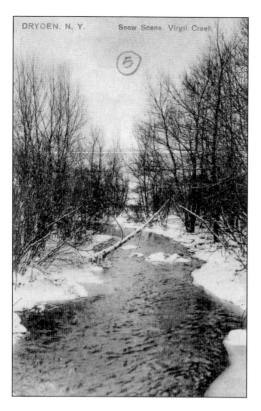

The seemingly docile Virgil Creek runs through the village of Dryden. There are a number of connecting streams within the village that conjoin with the creek creating a watershed for Cayuga Lake. (Author's collection.)

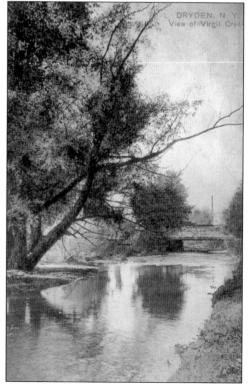

A light surface of ice is seen in this serene view of Virgil Creek as it passes through the village of Dryden. This almost glass-like appearance of the creek is very misleading; it has a history of turning into a disastrous, raging river. (Courtesy of Dryden Town Historical Society.)

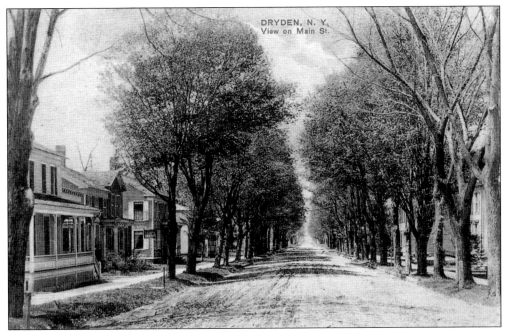

In a view looking down Main Street, a sign denoting "F.S. Howl, Dentist" sits on the corner of a home on the left side of the street. Even around 1910, Dryden was concerned with its community's health and well-being, as evidenced by the beautiful smiles pictured in vanity postcards. (Courtesy of Dryden Town Historical Society.)

Seen in this view looking west towards Ithaca, New York, the Dryden Woolen Mill gained its fame from manufacturing blankets for soldiers during the First World War. Now gone, the mill was once located where the West Main Street bridge crosses Virgil Creek, with a tendency for dangerous flooding throughout the years. (Author's collection.)

RESIDENCES ON MAIN STREET, Dryden, N. Y.

Houses line Main Street with newer concrete sidewalks and a curbed, hardtop road. This postcard image was taken sometime in the 1920s, based on the presence of both an automobile and a horse-drawn freight wagon. (Author's collection.)

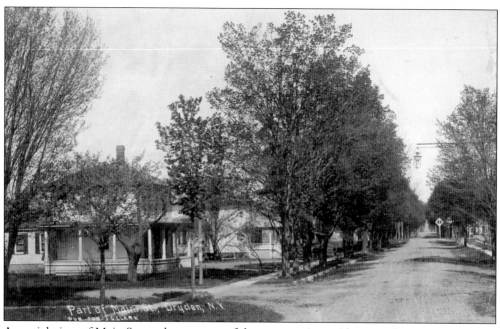

Part of Main St., Dryden, N.Y.

A partial view of Main Street shows more of the community residences. This view dates from before the new and improved hardtop roadways became the norm, though it still shows a hanging gaslight. (Courtesy of Dryden Town Historical Society.)

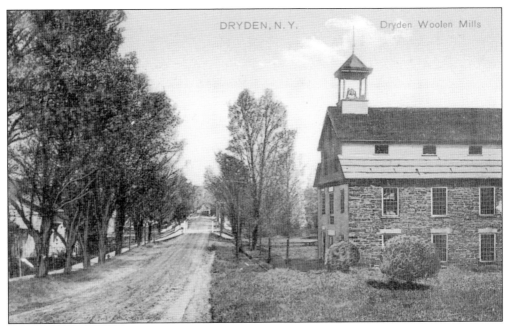

This is another view from before World War I of the nostalgic Dryden Woolen Mill on West Main Street. Many of that war's veterans owed their gratitude, and in part their survival, to this mill for its production of countless woolen blankets that were shipped with the men overseas during their service with the armed forces. (Author's collection.)

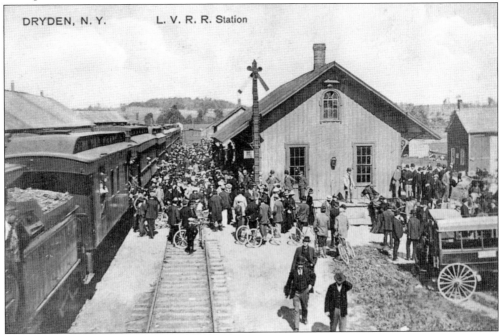

On this particular day in 1915, the Lehigh Valley Railroad station in the village of Dryden bustles with fairgoers exiting the many passenger cars. The riders are anxious to get to the renowned annual Dryden Agricultural Society Fair for a day filled with fun, entertainment, and various exhibits. (Courtesy of Dryden Town Historical Society.)

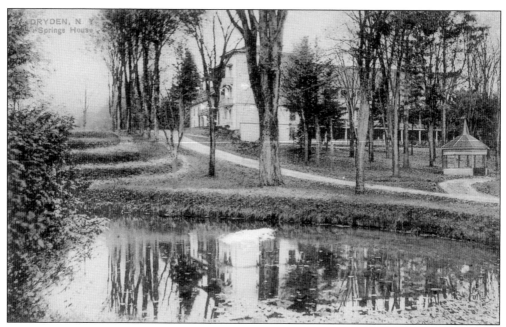

At the western edge of the village on Spring Street, the Dryden Spring Sanatorium could be found at the beginning of the 20th century. It was a resort hotel specializing in providing the "healing powers" of mineral water springs located on the property. After its closure, the structures were left to ruin until the hotel was destroyed by fire shortly after World War II. The cause of the fire is unknown, although it was suspected to have been accidently set by hobos off the railroad freight cars. (Author's collection.)

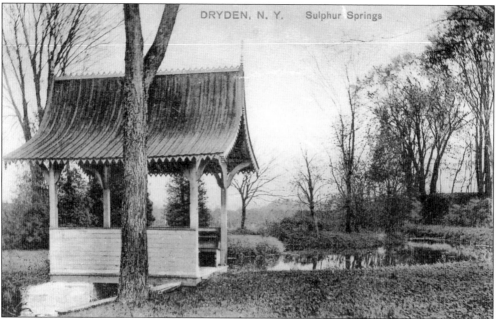

Placed scattered about the grounds of the Dryden Springs Sanatorium is one of several covered shelters. This particular spring was reputed to be especially rich with sulphur and was used for medicinal bathing and drinking. (Author's collection.)

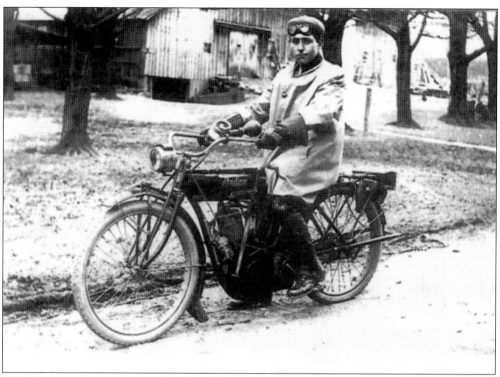

What better way to get around and see the many wonders found outside the village of Dryden than on a motorcycle? This young rider is all decked out with the latest riding fashion on his Indian motorcycle. Some of the safety equipment included a carbide headlamp, goggles, leather boots, gauntlet gloves, and a trusty "ooo-gah" horn. (Courtesy of Dryden Town Historical Society.)

Leaving the village of Dryden in 1912 and heading towards Ithaca, New York, the traveler was greeted by this bucolic view of a country roadside. Today, this is the path of New York State Route 13. (Courtesy of Dryden Town Historical Society.)

**J. H. HALE
MEAT DEALER
DRYDEN, N. Y.**

1912		SEPTEMBER			1912	
SUN	MON	TUE	WED	THU	FRI	SAT
1	2	3	4	5	6	7
8	9	10	11	12	13	14
15	16	17	18	19	20	21
22	23	24	25	26	27	28
29	30					

**I APPRECIATE
YOUR TRADE**

A meat dealer in Dryden shows his appreciation for trades he received by mailing folks a scenic monthly postcard. This one happens to be one of his September 1912 postcards. (Courtesy of Dryden Town Historical Society.)

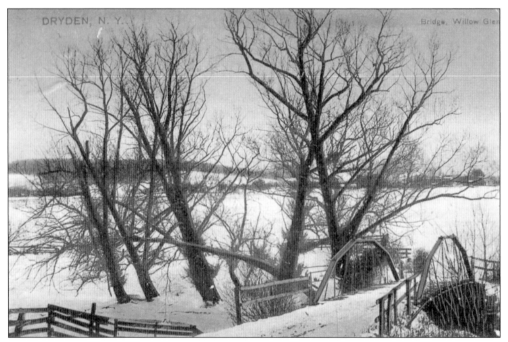

On the main road to Ithaca, New York, people drove across this bridge in the years before 1880. It was a one-lane bridge on a narrow dirt road along the route of what is still called the Bridle Path Road. The bridge has been lost due to modernization, and a box culvert has taken its place today. (Author's collection.)

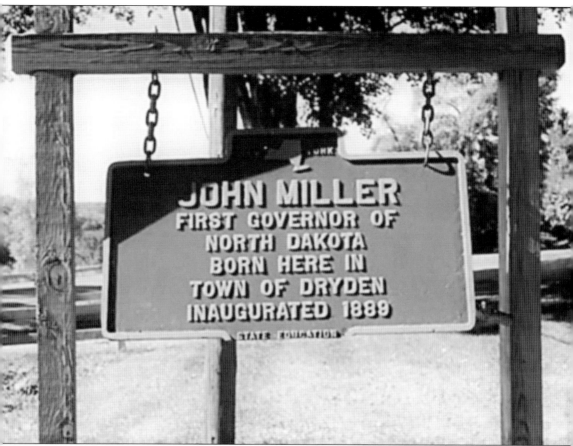

There is no picture postcard for this historical fact about the town of Dryden, but perhaps there should be one. John Miller, the first governor of North Dakota, was born here in Dryden. He went west to work with Dwight Enterprises and became the boy who left town and made good in the Wild West. (Courtesy of Dryden town historian H.L.D. Weldon.)

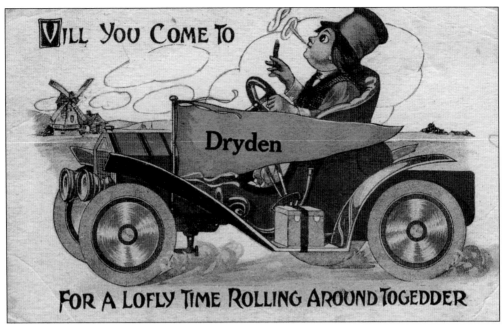

This humorous *korrespondenz karte* includes an invitation to visit and roll around Dryden in an automobile. (Author's collection.)

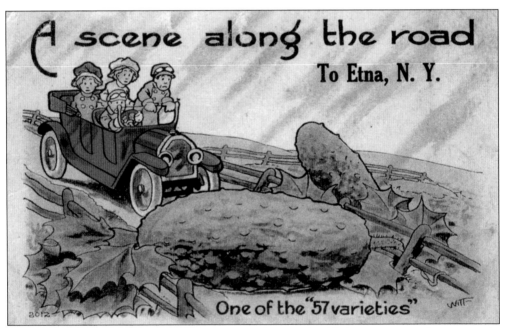

A delightful, humorous, and whimsical postcard boasts of unlikely gigantic produce grown in and around the hamlet of Etna. The fertile lands in this part of New York produced numerous varieties of produce, sometimes as many as "57 varieties" at a time. (Courtesy of Saino Judy Auble-Zarrara and Saino Zararra.)

Three

HAMLET OF ETNA

The hamlet was first called Miller's Settlement; this is referencing William Miller, who was one of the area's early settlers. In 1804, Miller's home also became the place where the first church in the area, under the Baptist denomination, was organized. Once the Baptist denomination was formally established, it became a reality, with a church built out of logs. Later, it was eventually replaced by a framed structure. Around the same time the Baptist church was established at William Miller's home, the hamlet saw its first sawmill built, as well as an informal bridge across Fall Creek. Sometime around 1815, Miller sold out everything to the Houtz family. This is when the name of the hamlet changed from Miller's Settlement to Columbia. It was not until around 1820 that the hamlet gained its current name of Etna with the establishment of the hamlet's official post office. The hamlet organized another church, this time under the Methodist Episcopal denomination, in 1835 next door to the Baptist church. The Methodist Episcopal church was eventually disbanded. After the disbandment, the steeple was removed and placed upon the Baptist church, where it resides currently. The rest of the structure still stands today as well; however, its use has changed. Currently, the former church building houses the Houtz Hall and the Etna Post Office. The Underground Railroad, both before and during America's Civil War, even had stops in Etna. On a road leading out of Etna, on the north side of Fall Creek, two homes bear roadside markers denoting them as part of the operation to aid fugitive slaves on their way to freedom in northern Free States or in Canada. One marker denotes the former home of Hananiah Wilcox and his wife, Nancy Ann Price, as a safe house station, and the other markers recognize the former home of William Hanford and his wife, Altha C. Todd, as another safe house.

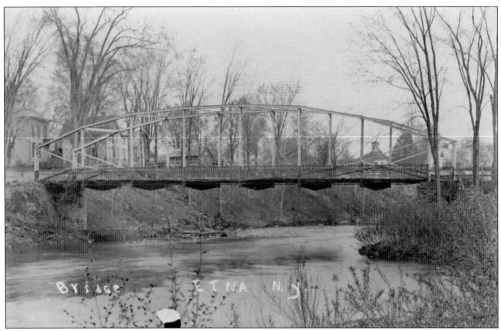

This is a long-ago view of the landmark bridge spanning Fall Creek in the center of the Hamlet of Etna, New York. The left side of the bridge led to the center of the hamlet, complete with two churches and a schoolhouse; the right side led to the Etna Roller Mills powered by the creek. (Courtesy of Saino Judy Auble-Zarrara and Saino Zararra.)

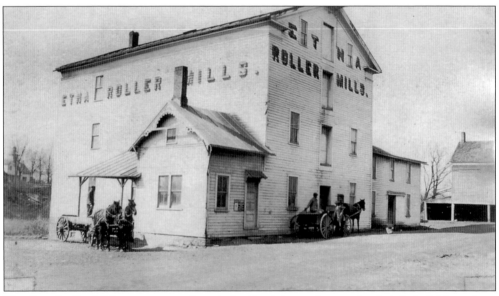

The Etna Roller Mills were once a busy hub of activity, as farmers hauled their field products to be milled by the operations shown here in 1915. By the 1950s, this site had become a retail lumber business outlet. Today, it is recognized as the Etna Mill Apartments. (Courtesy of Saino Judy Auble-Zarrara and Saino Zararra.)

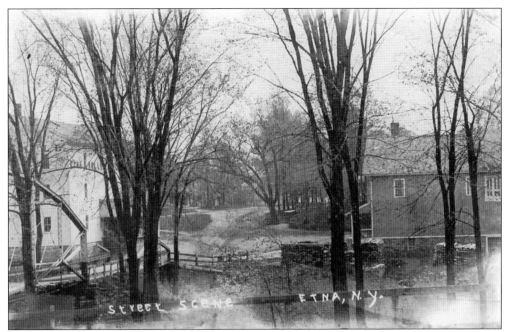

This is a 1909 panoramic view of the four main streets at the epicenter of Etna. The mill, creek, and the only general store are on the right side of the postcard. (Courtesy of Saino Judy Auble-Zarrara and Saino Zararra.)

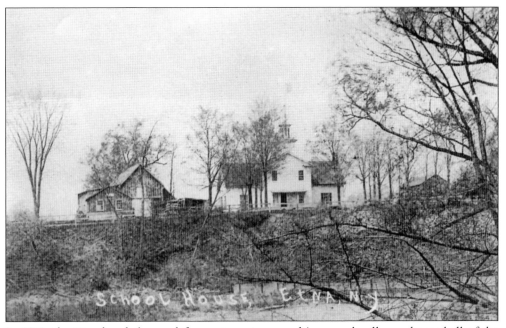

In 1910, the Etna hamlet's wood-frame, two-story, multiroom schoolhouse housed all of the elementary grade levels. It became a part of the Dryden Central School District during the 1935 centralization process. In later years, it was abandoned and demolished when deemed to no longer be adequately meeting the needs of the centralized system. (Courtesy of Saino Judy Auble-Zarrara and Saino Zararra.)

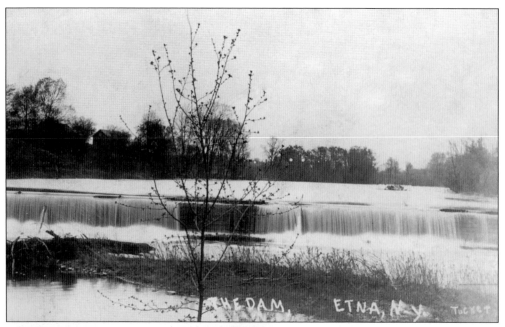

A bit upstream from the hamlet's bridge, this 1914 view shows the water cascading over the dam that supplied water to power the Etna Mill. In the early years of the 1900s, the dam area was a beloved recreational site for local residents. Sadly, the dam went out with the big creek flood of 1927. (Courtesy of Dryden Town Historical Society.)

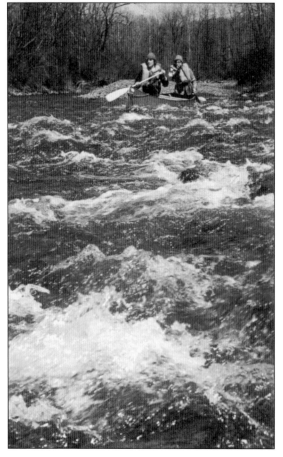

Years after the dam went out in a high-water flood, Fall Creek became popular for canoe racing. In the 1960s, the creek was world-renowned as a location for annual white-water canoe and kayak racing in the springtime. (Author's collection.)

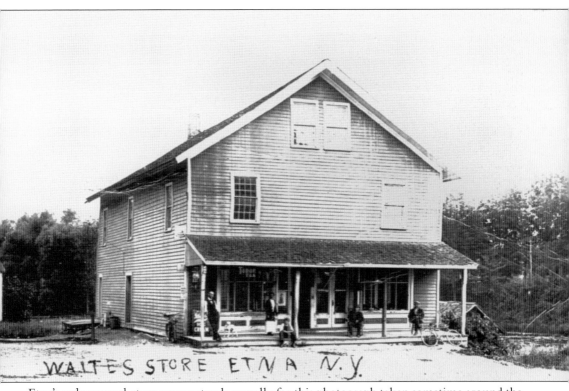

Etna's only general-store owner stands casually for this photograph taken sometime around the 1920s. The posture of the people is symbolic of the Etna community's laid-back nature, which remains so still to this day. (Author's collection.)

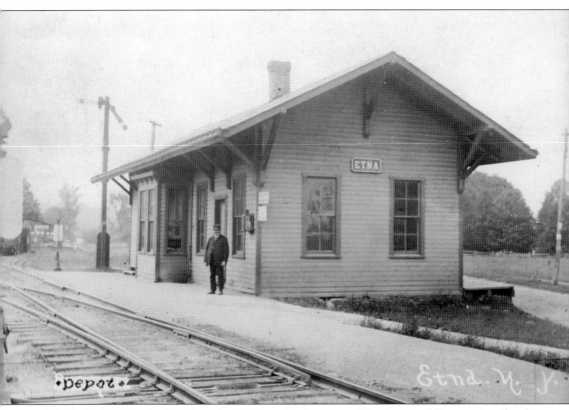

The Lehigh Valley Railroad station in Etna has its agent, Charles Spaulding, posing for the camera in this 1911 photograph. This depot was the exchange point for the Etna community's needs for goods and produce, as well as a connecting point for traveling. (Courtesy of Saino Judy Auble-Zarrara and Saino Zararra.)

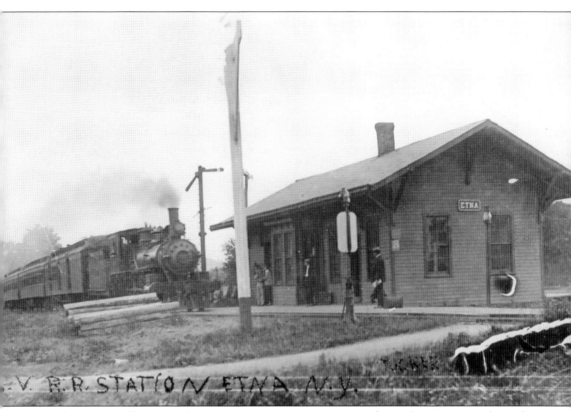

A daily train is pulling into the Etna station carrying passengers from Ithaca, New York. Such daily trains would have carried passengers, freight, express mail, and specials, such as milk. (Courtesy of Saino Judy Auble-Zarrara and Saino Zararra.)

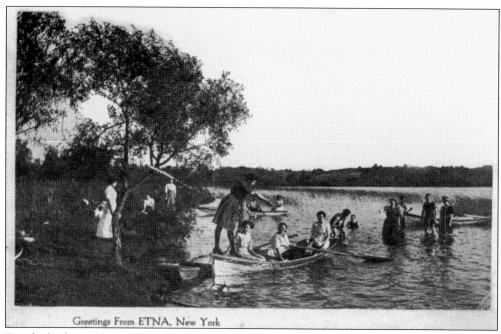

Greetings From ETNA, New York

Etna had a dam and recreational park across the Fall Creek until it was washed out during a flash flood in 1927. On a typical leisurely summer day, many would gather to partake in activities such as boating and swimming. Note the cumbersome swim outfits that were the fashion in those days gone by. (Courtesy of Saino Judy Auble-Zarrara and Saino Zararra.)

A depiction of a romantic afternoon outing along a secluded shoreline scene would have often been mailed as a thoughtful little note. (Courtesy of Dryden Town Historical Society.)

Four

VILLAGE OF FREEVILLE

For the first half of the 1800s, the village of Freeville was nothing more than a rural countryside with a few houses scattered about. The houses were the homes of the owners and workers of the scattered gristmills, cloth works, and sawmills that were located along the banks of Fall Creek, which passes through the center of present-day Freeville. These businesses and houses were established even before the village of Dryden itself was incorporated in 1857. Although the village of Freeville was not officially incorporated until 1887, with a population of approximately 300, the area saw its first church erected in 1848 under the Methodist Episcopal denomination in what is now considered "Old Freeville." The "New Freeville" was established around 1872 based on the coming of a rather large railroad junction. Since then, the area has blossomed with houses and businesses. At one time, the villages of Dryden and Freeville had a friendly competition to be the bigger village. Although Dryden came out on top, Freeville had a large five-branched railroad junction of the Lehigh Valley Railroad going for it. Of the five branches, one went to the village of Dryden; another to Ithaca, New York, with a stop in Etna along the way; a third headed toward Cortland, New York, through Malloryville; another went onwards to Auburn, New York, through Peruville, New York; and the fifth went through West Dryden on its way to Geneva, New York (this branch was abandoned by 1892). The rest of the Lehigh Valley Railroad was scrapped and completely gone by 1979. The entire village itself is fortunate with its water supply. The low-lying area makes the village naturally prone to artesian wells. The flip side to the bountiful water supply is that the area is also considered flat-bottomed, which makes some localized areas susceptible to flooding. Later generations can recall a display of a stuffed polar bear in a long-gone gun shop owned by Bob Hughes. The 2010 US census reported a population of 520. The village today stands as a quaint, one-square-mile community with a booming ice-cream shop and a few select other businesses, including a Greek/Italian restaurant.

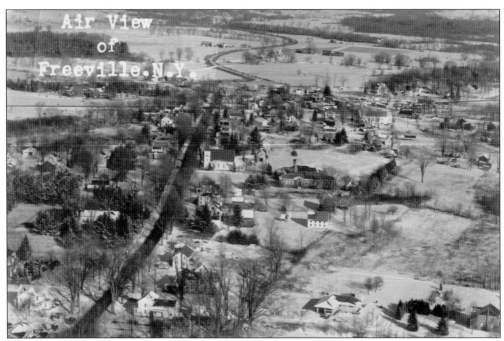

This aerial view of Freeville looks north toward McLean, New York. In the center, the Freeville Methodist Episcopal Church and the Freeville schoolhouse are visible. (Courtesy of Dryden Town Historical Society.)

Pictured around the late 1930s, the four corners of Freeville, New York, are seen in this view looking east toward the village of Dryden. In the background are the four branch crossings of the Lehigh Valley Railroad yards: Auburn, Ithaca, Cortland, and Owego. (Courtesy of Dryden Town Historical Society.)

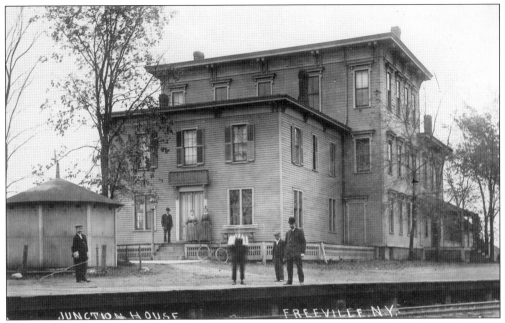

The Junction House served the railroad travelers and the community as a hotel. Seen here are those who worked at the hotel and others who worked nearby, posing for the photographer to record a moment in time. (Courtesy of Dryden Town Historical Society.)

A picnicker sits enjoying her time in the village of Freeville park sometime in the late 1950s. It appears to be a lovely, warm, sunny day for a little solitude. (Courtesy of Dryden Town Historical Society.)

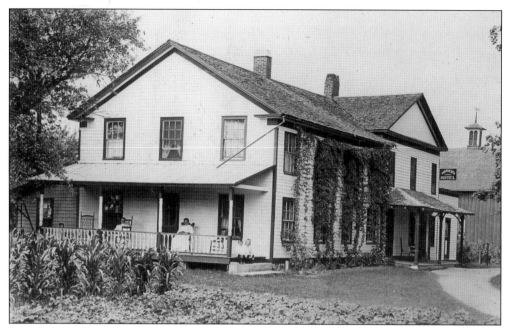

Guests donned in their finer garments sit relaxing on the shady porch. They are posing for this photographer for generations to recall the eloquent days of the long-ago Shaver Hotel. (Courtesy of Dryden Town Historical Society.)

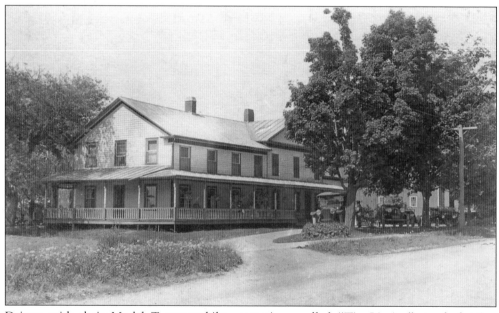

Drivers with their Model T automobiles, sometimes called "Tin Lizzies," stand chatting under the shade in front of the Shaver Hotel. The ladies and gentlemen are likely separated to converse with one another about their own gendered interests. (Courtesy of Dryden Town Historical Society.)

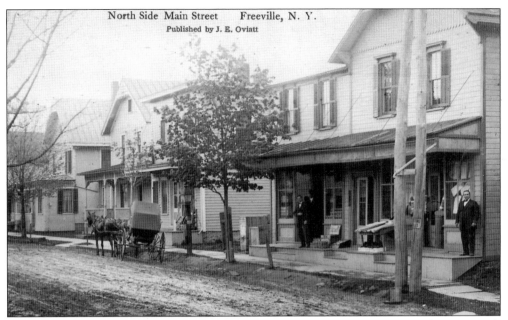

The north side of Main Street in Freeville, New York, features a duplex storefront. At each entrance door, the store's proprietors stand proudly for their photograph. (Courtesy of Dryden Town Historical Society.)

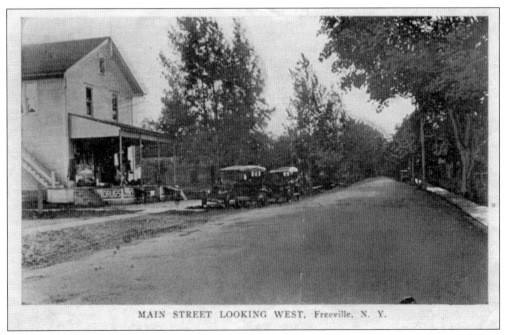

Business is booming on the main street, as evidenced by the automobiles parked along the curbside. Trees are in full bloom, making for a nice time to dash into the store for an ice-cold soda, a brief catch-up on the local news, or to grab a few groceries for the home. (Courtesy of Dryden Town Historical Society.)

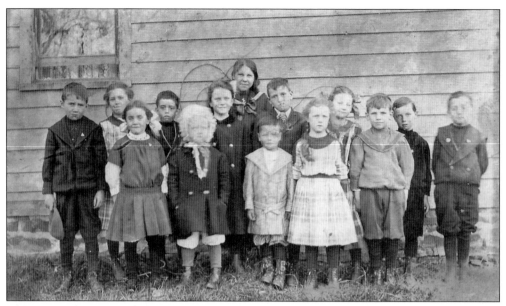

The identification of this group of children as being as a class at the Freeville School in the town of Dryden has not been verified. Having their picture taken seems to have resulted in mixed emotions, as evidenced by the children's various facial expressions. (Courtesy of Dryden Town Historical Society.)

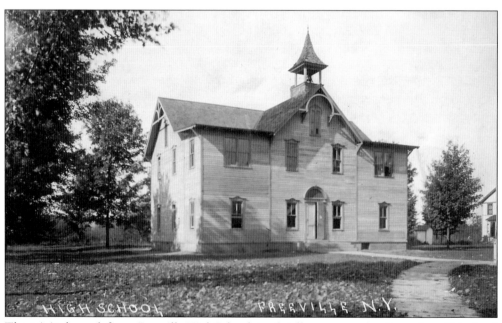

The original wood-frame Freeville High School stands tall on a sunny day. It was demolished and replaced with the current brick schoolhouse that is now the Freeville Elementary School within the Dryden Central School District system. (Courtesy of Dryden Town Historical Society.)

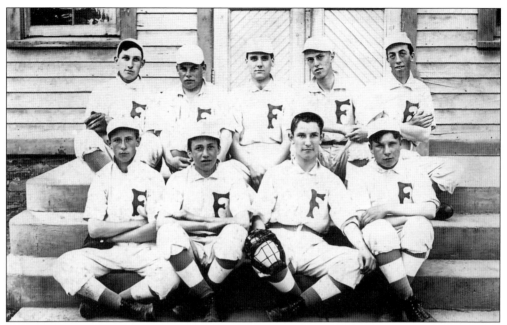

A Freeville High School baseball team poses for the photographer sometime before 1935. Dressed in their uniforms, the players may have been grabbed for a team photograph on their way to the field to play ball. (Courtesy of Dryden Town Historical Society.)

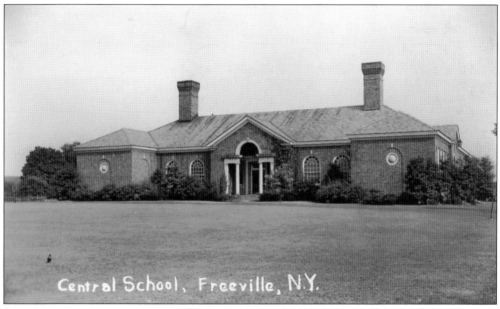

The original wood-frame high school was replaced with this exquisite brick building. In 1935, Freeville merged with the Dryden school system. For a short period, this brick central schoolhouse included all grades. The structure still stands today, although it is now used as an elementary school. (Courtesy of Dryden Town Historical Society.)

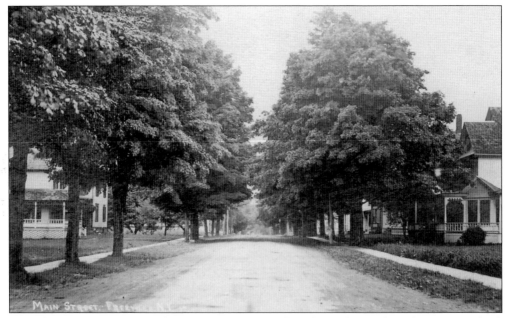

This charming view is one of Main Street in Freeville. Elegant houses line the street on both sides. (Courtesy of Dryden Town Historical Society.)

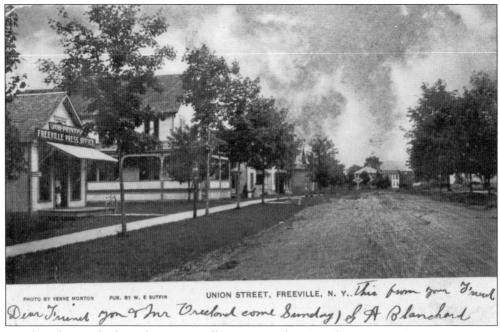

Another pleasant-looking day in Freeville is seen in this view down Union Street many years ago. Visible is the sign of the Freeville Press Office that did printing jobs. (Courtesy of Dryden Town Historical Society.)

A stately house blends right in with all the snow the village of Freeville receives. On the corner stands a knickers-wearing adolescent lad. (Courtesy of Dryden Town Historical Society.)

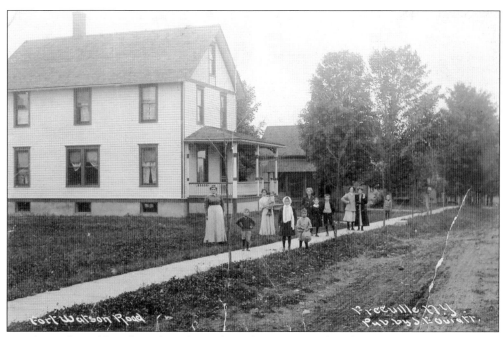

Families and neighbors happily gather to have their picture taken for a picture postcard. A note on the postcard states that it was taken on Fort Watson Road; however, this road name is not used today. (Courtesy of Dryden Town Historical Society.)

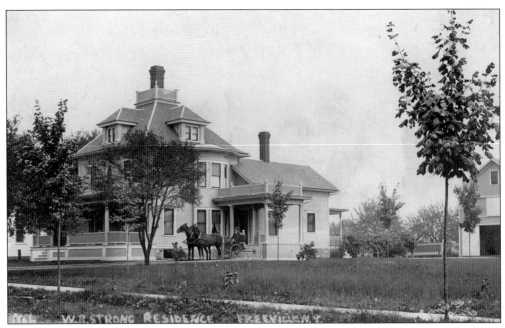

W.B. Strong sits proudly in his classic horse-drawn buggy at the ready for a drive. He was a prominent Freeville resident for whom the Freeville Fire Department is named. (Courtesy of Dryden Town Historical Society.)

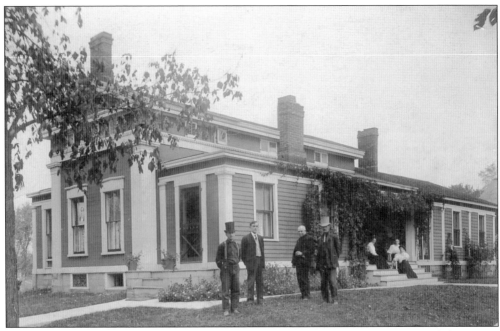

Dapper gentlemen stand on the corner of this one-and-a-half-story house. One of the men is enjoying a stogie cigar. The fair ladies sit back on the steps chatting during the whole process of taking a photograph. (Courtesy of Dryden Town Historical Society.)

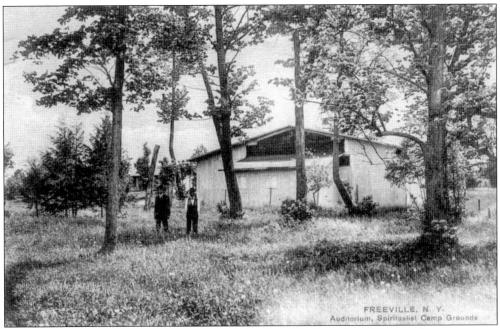

Within its boundaries, Freeville housed a Spiritualist Association Campground. This association was comprised, in short, of paranormal followers. Shown here are two men standing in front of the association's auditorium. (Courtesy of Dryden Town Historical Society.)

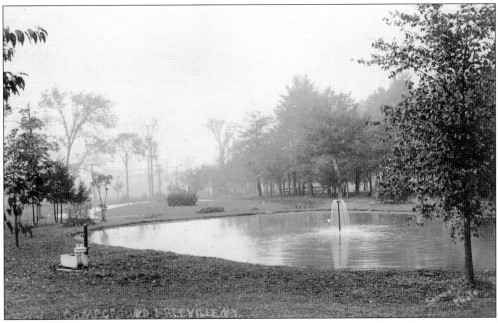

The Freeville Spiritualist Association showcased an artesian spring–fed pond in the center of its campground. The camp and its pond are located on the outskirts of the four corners of the village, enclosed by a circular drive exiting onto the main road. (Courtesy of Dryden Town Historical Society.)

This is an example of a "vanity" postcard, as described in the introduction. This family farm is located near the Malloryville Road in the area of the first town road built in 1795. (Courtesy of Dryden Town Historical Society.)

Five

GEORGE JUNIOR REPUBLIC

William Reuben George (1866–1936) was a native of West Dryden. He found himself in New York City as a businessman. While in the city, he began to notice the organized crime and gangs. He finagled his way to structure them more into proper citizens rather than criminals. By the summer of 1890, George was through with the urban life and took 22 children from the city back upstate to his original roots, where the air was fresh and the grass was lush. He obtained funds from the *New York Tribune*, which financed The Fresh Air Fund, to help pay for his own program. For the next several years, W.R. George continued to bring minors from the city upstate until 1895. This was the year that he decided he was through with the city and would brave the harsher upstate winter weather, along with five other volunteers, to found a permanent "colony" in Freeville called the George Junior Republic. It was parallel to the rest of the state's economic, civic, and social conditions with one exception: its focus was on neglected and wayward youth. The George Junior Republic was its own colony that was run by the youth, from the laws to the economic system. It was its own little community, complete with its own currency issued as scrip valid only on the republic's grounds. The initial grounds were that of a farm purchased by George. In the republic's early years, the work required to keep the farm running slowly led to his founding motto, "Nothing without labor." The youth he took in as residents respectfully referred to the founder as their "Daddy George." As the years progressed, the George Junior Republic gained a lot of attention for George's leadership and accomplishments with the youth residents.

He was visited by, on separate occasions, Franklin and Eleanor Roosevelt, Theodore Roosevelt, and others like Lord Baden Powell, the founder of the worldwide Scouting movement for youth, and Alexander Forbes of *Forbes* magazine. The attention was drawn to the republic by such significant figures in part by the prestigious accomplishments many of the early citizens went on to have. The accomplishments included those of a Supreme Court justice, a legislator in California, the winner of a Pulitzer Prize, a recipient of an Academy Award, and many others who served and made the ultimate sacrifice during both world wars and other wartime conflicts. The original George Junior Republic motto has evolved over time. In 2005, it received a brand-new name: the William R. George Agency for Children's Services, Inc. With the name change, there was also a change in the ideals. It has become less labor-intensive and more centralized on education and psychological intervention, yet still focuses on social development to make its citizens more well-rounded and responsible adults when they leave. The 2005 name change also marked the beginning of another era—one in which those with normal cognitive functionalities and those with intellectual, emotional, and mental disabilities became more separated in order for those that required it to receive specialized services more tailored to their specific needs. This replaced the one-diagnosis-fits-all concept. Not much is publicly known about the republic's number of residents, although it can be noted that, between 1994 and 2014, the agency increased vastly in size from 45 resident citizens' beds up to 189 beds to further serve the wayward youth of New York State.

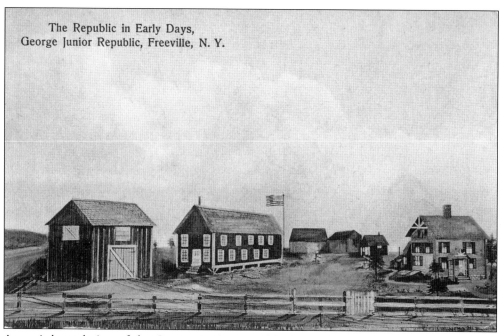

The Republic in Early Days,
George Junior Republic, Freeville, N. Y.

An artist's rendering of the George Junior Republic in its early days was used as a picture postcard. (Courtesy of archivist "Trish" Sprague at William R. George Agency.)

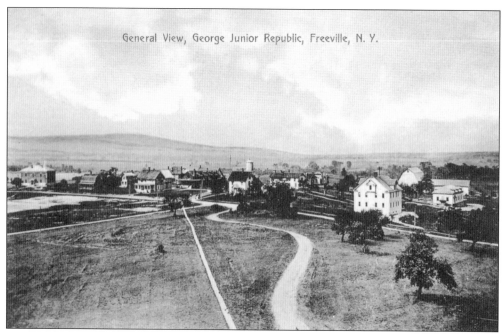

General View, George Junior Republic, Freeville, N. Y.

This is a sort of a bird's-eye view of the George Junior Republic campus in its early days, around 1905. (Courtesy of archivist "Trish" Sprague at William R. George Agency.)

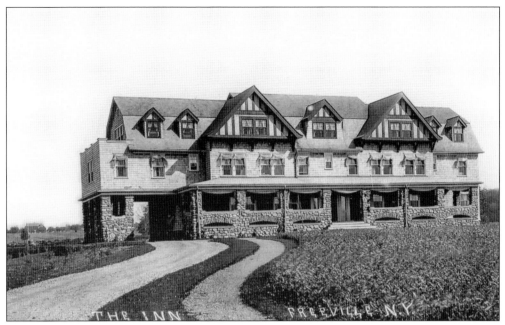

The Inn was once an important main building at the George Junior Republic. It was once recognized as a Freeville, New York, landmark. The grand building has been replaced recently. In its place stands a dormitory building for youth residents that meets today's building and safety codes and specification requirements. (Courtesy of Dryden Town Historical Society.)

Still the same building, the Inn appears to have been relocated in this postcard. In reality, it is actually the same view of the same building in the same location only three decades later. The trees and shrubs had grown in over the years to further add beauty to the grand structure. (Courtesy of Dryden Town Historical Society.)

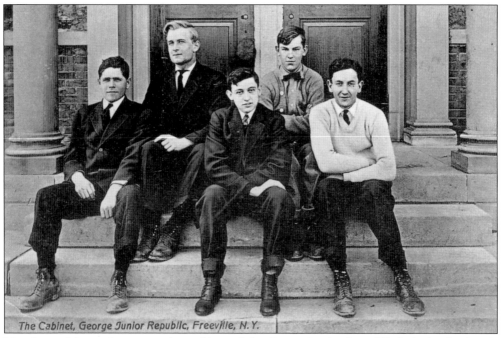

Members of the student governing cabinet of the George Junior Republic in its beginning sit on the stairs with the senior gentleman, founder William R. "Daddy" George. (Courtesy of archivist "Trish" Sprague at William R. George Agency.)

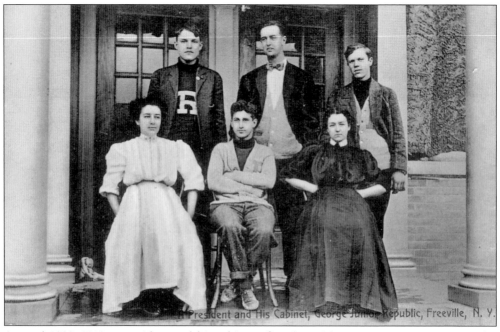

Around 1890–1910, a president and his cabinet of student citizens pose at an entrance to be photographed. (Courtesy of archivist "Trish" Sprague at William R. George Agency.)

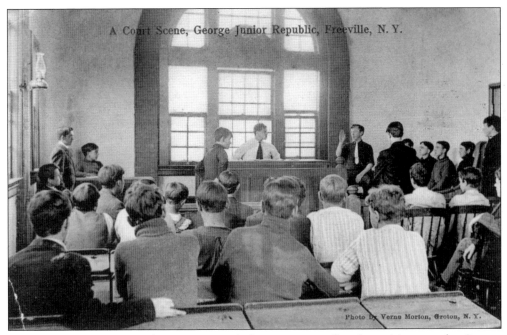

This c. 1910–1920 postcard portrays a typical court scene of student citizens at the George Junior Republic practicing good citizenship. (Courtesy of Dryden Town Historical Society.)

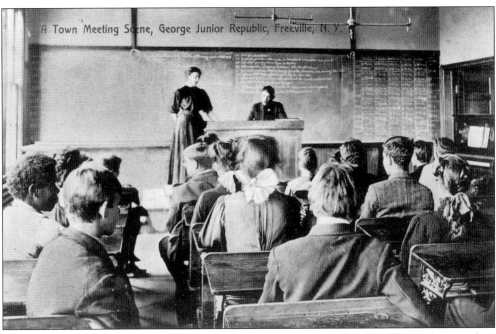

A town meeting is being held at the George Junior Republic by its resident student citizens, monitored by an advisor. (Courtesy of archivist "Trish" Sprague at William R. George Agency.)

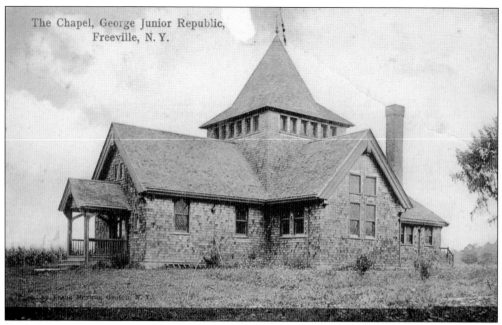

The Chapel, George Junior Republic, Freeville, N.Y.

Photographed sometime before 1930, this unique interfaith chapel belongs to the George Junior Republic. (Courtesy of archivist "Trish" Sprague at William R. George Agency.)

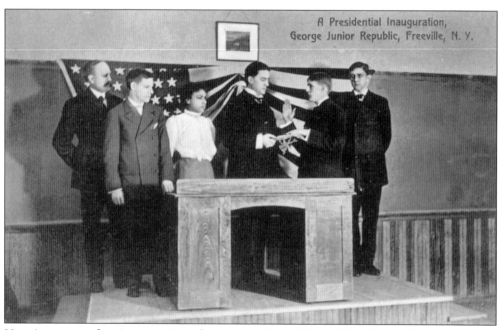

A Presidential Inauguration, George Junior Republic, Freeville, N.Y.

Here is a scene of an inauguration of a new youth president of the George Junior Republic. The man standing on the left is founder William R. George. (Courtesy of Dryden Town Historical Society.)

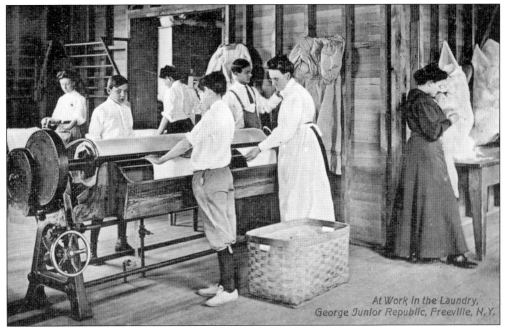

Citizens are diligently at work in the laundry room around 1900 at the George Junior Republic. (Courtesy of archivist "Trish" Sprague at William R. George Agency.)

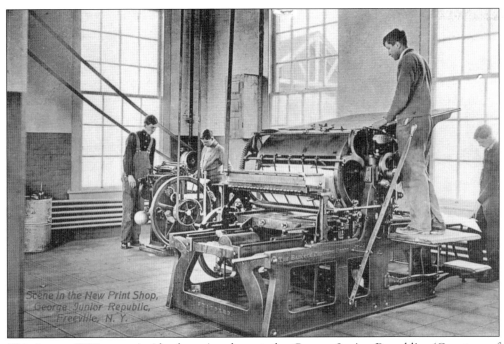

This is a c. 1920 scene inside the print shop at the George Junior Republic. (Courtesy of archivist "Trish" Sprague at William R. George Agency.)

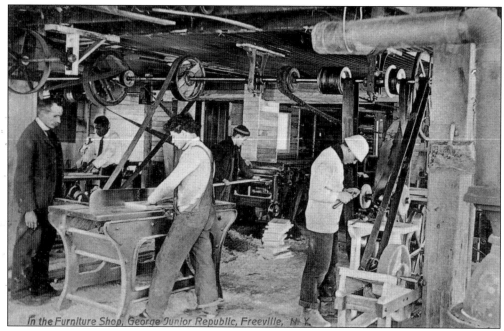

Inside the furniture shop at the George Junior Republic, a mentor stands guiding a citizen into the furniture-making trade. (Courtesy of archivist "Trish" Sprague at William R. George Agency.)

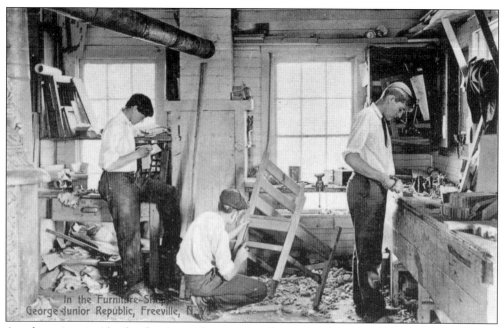

Another view inside the furniture shop at the George Junior Republic shows its citizens practicing assembling mortise joints. (Courtesy of archivist "Trish" Sprague at William R. George Agency.)

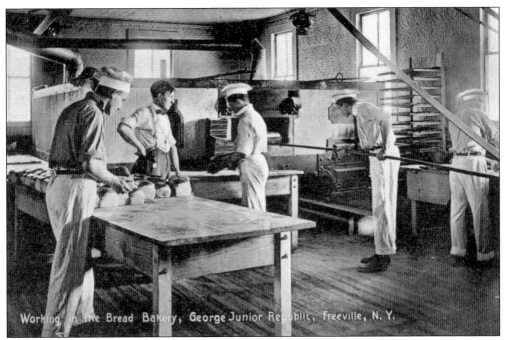

Working inside the bread bakery at the George Junior Republic, citizens are practicing the art of baking bread. (Courtesy of archivist "Trish" Sprague at William R. George Agency.)

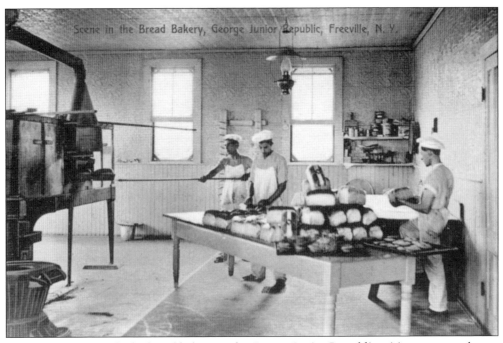

In another scene inside the bread bakery at the George Junior Republic, citizens remove loaves from the ovens to prepare them for shipment. (Courtesy of archivist "Trish" Sprague at William R. George Agency.)

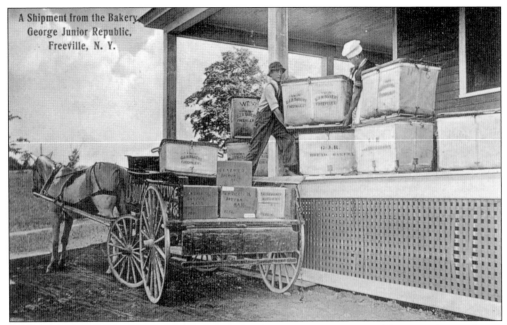

Two citizens load a shipment from the bakery at the George Junior Republic into a horse-drawn delivery wagon. (Courtesy of archivist "Trish" Sprague at William R. George Agency.)

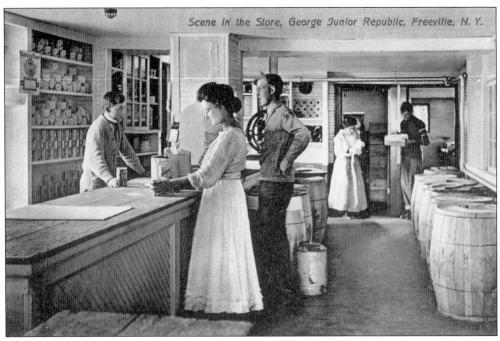

George Junior Republic citizens are purchasing goods at the campus store, run and operated by other citizens. The citizens would use their earned George Junior Republic–issued scrip currency received for their labor elsewhere on the campus. (Courtesy of archivist "Trish" Sprague at William R. George Agency.)

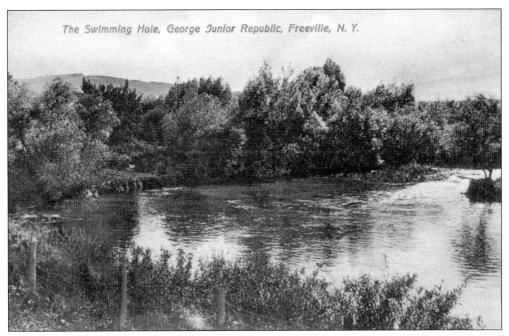

The Swimming Hole, George Junior Republic, Freeville, N. Y.

This is the old swimming hole on the campus of the George Junior Republic. (Courtesy of archivist "Trish" Sprague at William R. George Agency.)

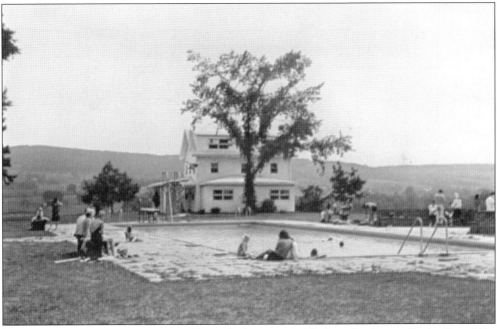

The Philip H. Lehman Memorial Pool is today's swimming hole at the George Junior Republic. (Courtesy of archivist "Trish" Sprague at William R. George Agency.)

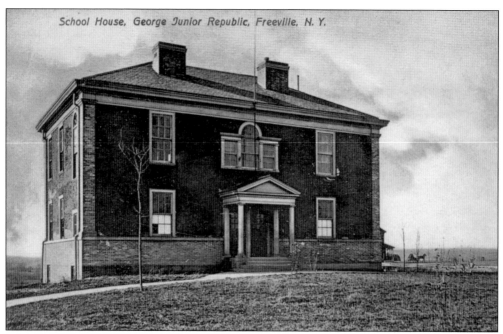

The former high school house is seen in this view at the George Junior Republic. (Courtesy of archivist "Trish" Sprague at William R. George Agency.)

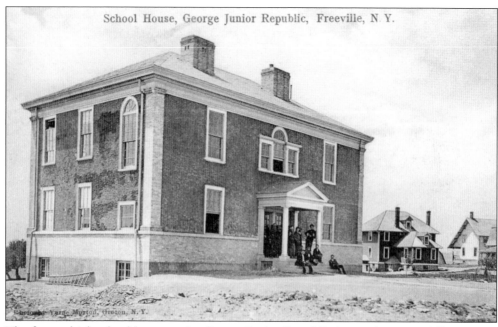

The former high school house at the George Junior Republic is seen here at a different time in a similar view. It has since been replaced a modern school building. (Courtesy of archivist "Trish" Sprague at William R. George Agency.)

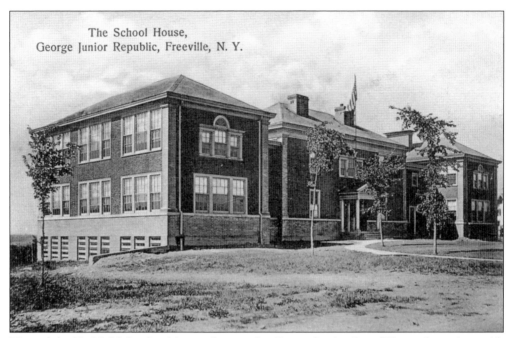

The original brick high school is seen here at the George Junior Republic at a later time with two large additional wings. It has since been replaced by a more modern structure. (Courtesy of archivist "Trish" Sprague at William R. George Agency.)

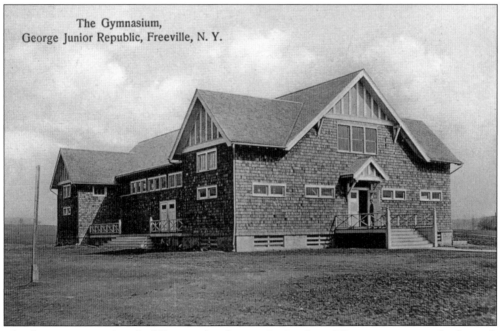

The former gymnasium building at the George Junior Republic was constructed of wood. Today, the wooden structure still stands, although it has since become an administration building. (Courtesy of archivist "Trish" Sprague at William R. George Agency.)

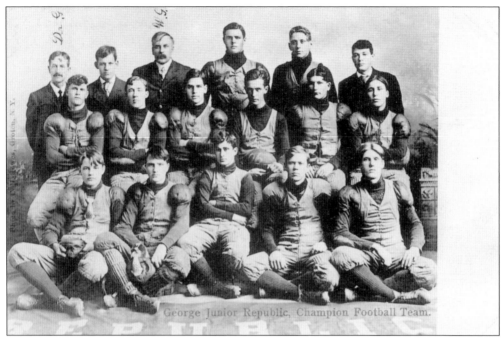

A champion football team at the George Junior Republic pose with "Daddy George," third from left in the back row. (Courtesy of Dryden Town Historical Society.)

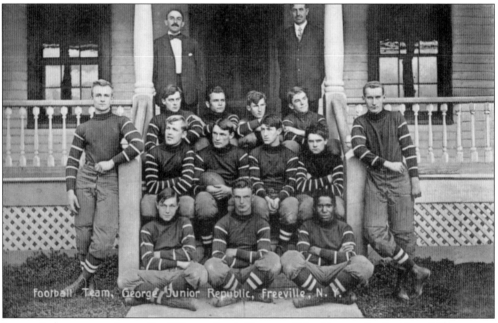

In another year, members of a different football team of the George Junior Republic pose on the steps of one of the many buildings on the campus. The two unidentified gentlemen in the back row are likely the coaches of the team. (Courtesy of archivist "Trish" Sprague at William R. George Agency.)

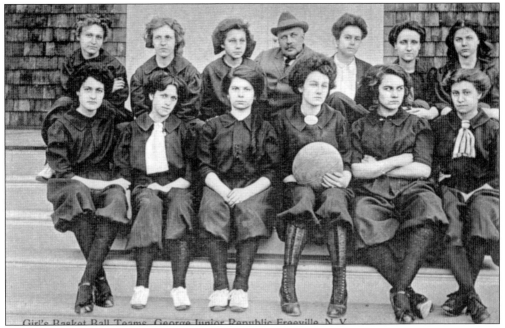

This photograph shows the "girl's basket ball teams" of the George Junior Republic. The gentleman seated in the middle of the back row is founder "Daddy George" himself. (Courtesy of archivist "Trish" Sprague at William R. George Agency.)

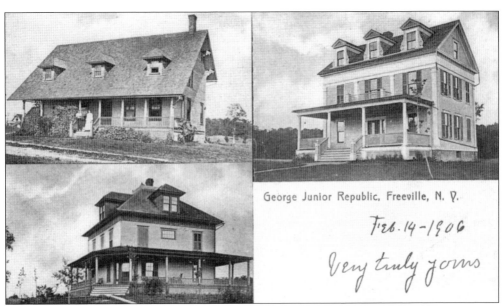

George Junior Republic, Freeville, N. Y.

Feb. 14-1906

Very truly yours

Here are three of the many citizens' residential houses at the George Junior Republic, some of which still stand to this day and carry on the mission of the republic. (Courtesy of archivist "Trish" Sprague at William R. George Agency.)

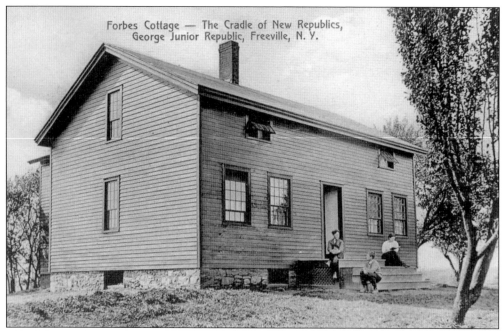

Forbes Cottage — The Cradle of New Republics,
George Junior Republic, Freeville, N. Y.

All of the residential houses at the George Junior Republic had their own names. This one, in particular, happens to be called Forbes Cottage. (Courtesy of archivist "Trish" Sprague at William R. George Agency.)

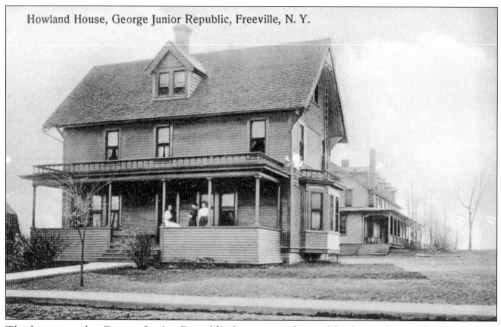

Howland House, George Junior Republic, Freeville, N. Y.

The houses at the George Junior Republic have never housed both genders at the same time. The Howland House happened to be for young lady citizens. (Courtesy of archivist "Trish" Sprague at William R. George Agency.)

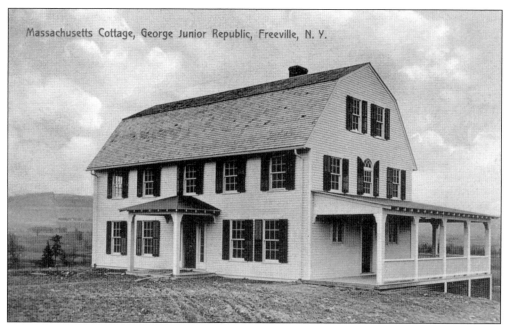

Massachusetts Cottage, George Junior Republic, Freeville, N. Y.

This residential house at the George Junior Republic, called the Massachusetts Cottage, is still in use today, minus the end porch. It is also a local landmark. (Courtesy of archivist "Trish" Sprague at William R. George Agency.)

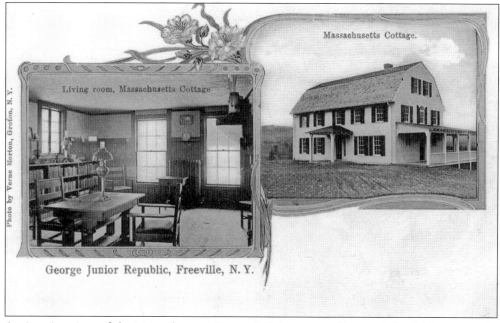

Living room, Massachusetts Cottage

Massachusetts Cottage.

Photo by Verne Morton, Groton, N. Y.

George Junior Republic, Freeville, N. Y.

An interior view of the Massachusetts Cottage's living room décor and furnishings show its dependency on study, in the early days of the George Junior Republic. (Author's collection.)

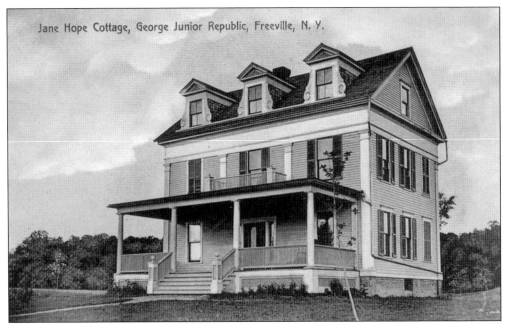

This citizen's residence was named Jane Hope Cottage during the early days of the George Junior Republic. (Courtesy of archivist "Trish" Sprague at William R. George Agency.)

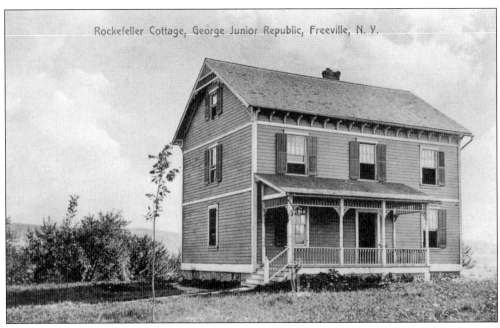

In its early days, this residence for citizens at the George Junior Republic was named Rockefeller Cottage. (Courtesy of archivist "Trish" Sprague at William R. George Agency.)

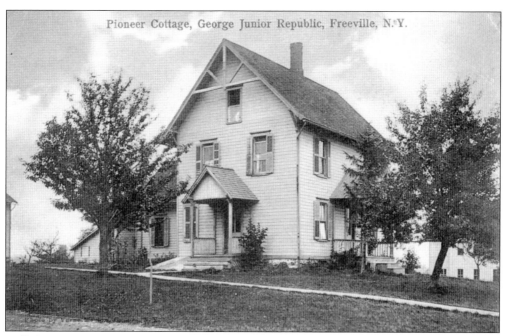

Called Pioneer Cottage, this building at the George Junior Republic was another citizen's residence. (Courtesy of Dryden Town Historical Society.)

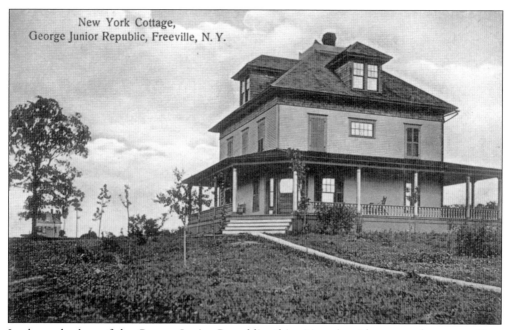

In the early days of the George Junior Republic, this citizens' residence was known as New York Cottage. (Courtesy of archivist "Trish" Sprague at William R. George Agency.)

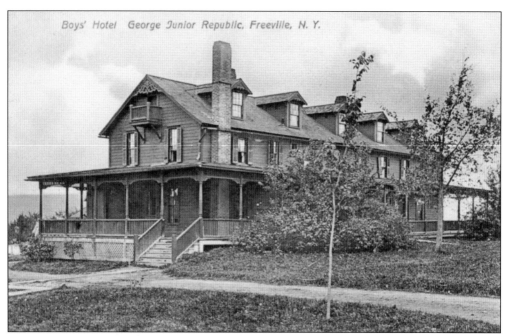

Both genders had their own separate hotels, which were used as temporary citizen housing. This photograph shows the former Boys' Hotel at the George Junior Republic. (Courtesy of archivist "Trish" Sprague at William R. George Agency.)

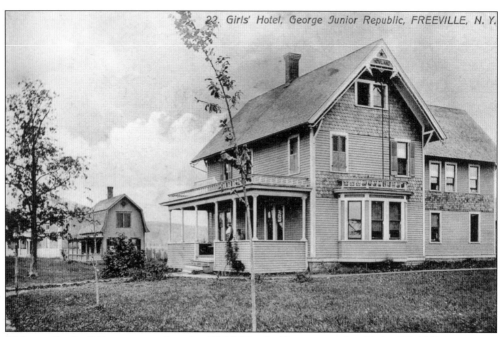

This smaller building was used as the Girls' Hotel. (Courtesy of archivist "Trish" Sprague at William R. George Agency.)

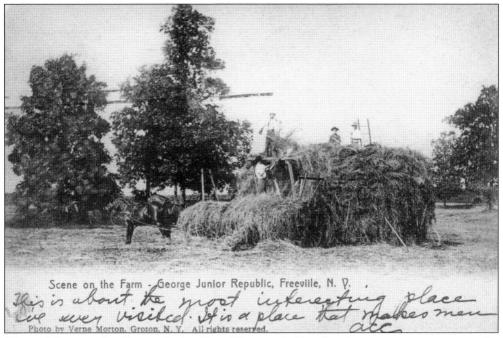

These citizens at the George Junior Republic are pitching hay into a wagon to support the republic's livestock. The backbreaking work portrayed here reflects the underlying mission in keeping with the motto that "Daddy George" predicated, "Nothing without labor." (Courtesy of Dryden Town Historical Society.)

W. R. George Res., G. J. R., Freeville, N.Y.

A departing view of the George Junior Republic shows the founder's residence that is adjacent to the concreted state highway sometime in the 1930s. Sadly, the beloved "Daddy George" passed away in 1936. (Courtesy of Dryden Town Historical Society.)

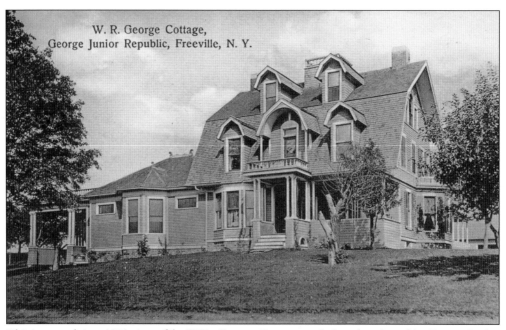

W. R. George Cottage,
George Junior Republic, Freeville, N. Y.

This is a nostalgic c. 1910 view of the W.R. George Cottage nestled on the edge of the George Junior Republic campus. (Courtesy of archivist "Trish" Sprague at William R. George Agency.)

Greetings from Dryden

This postcard was one of those whimsical postcards often mailed to someone who might be thought of in some distant place. (Courtesy of Dryden Town Historical Society.)

Bibliography

Alvarez, Lenore. *Freeville Centennial 1887–1987 Program & Self-Guided History Tour of Freeville.* Freeville, NY: 1987.

Clark, Betsey L. *History of Dryden (From 1797 to 1897 by the Old Man in the Clouds).* Ithaca, NY: DeWitt Historical Society of Tompkins County, Inc., 1961.

Cloyes, Samuel A. *The Healer (The Story of Dr. Samantha S. Nivison and Dryden Springs, 1820–1915).* Ithaca, NY: DeWitt Historical Society of Tompkins County, 1969.

Church Centennial Committee. *The Centennial History of the First Presbyterian Church of Dryden.* Dryden, NY: Stilwell & Ross Printers, c. 1908.

Dieckmann, Jane Marsh. *A Short History of Tompkins County.* Ithaca, NY: 1986.

Genung, Albert Benjamin. Edited by Rachel D. Savage. *Historical Sketch of the Village of Freeville Tompkins County New York.* Freeville, NY: 1987.

Goodrich, George B. *The Centennial History of the Town of Dryden (1797–1897).* Dryden, NY: The Dryden Herald Steam Printing House, 1898.

Gutchess, Elizabeth Denver. *Dryden's Second Hundred Years (1897–1942).* Lincoln, NE: iUniverse, Inc., 2006.

Kammen, Carol. *The Peopling of Tompkins County.* Interlaken, NY: Heart of the Lakes Publishing, 1985.

———. *Place Names of Tompkins County.* Ithaca, NY: 2004.

Municipal Historians of Tompkins County. *Tompkins County New York: Images of Work and Play.* Charleston, SC: The History Press, 2009.

Norris, W. Glenn. *Early Explorers and Travelers in Tompkins County.* Ithaca, NY: DeWitt Historical Society, 1961.

Selkreg, John H. *Landmarks of Tompkins County.* Syracuse, NY: D. Mason & Company, 1894.

Trapp, Stella M. *Dryden High School Then and Now* Ithaca, NY: DeWitt Historical Society, 1963.

Waterman, David. *Who Was This Amos Sweet?* Akron, OH: 48 Hr Books, 2017.

DISCOVER THOUSANDS OF LOCAL HISTORY BOOKS FEATURING MILLIONS OF VINTAGE IMAGES

Arcadia Publishing, the leading local history publisher in the United States, is committed to making history accessible and meaningful through publishing books that celebrate and preserve the heritage of America's people and places.

Find more books like this at
www.arcadiapublishing.com

Search for your hometown history, your old stomping grounds, and even your favorite sports team.

Consistent with our mission to preserve history on a local level, this book was printed in South Carolina on American-made paper and manufactured entirely in the United States. Products carrying the accredited Forest Stewardship Council (FSC) label are printed on 100 percent FSC-certified paper.

MADE IN THE